The SOLWAY COAST

H. C. IVISON

AMBERLEY

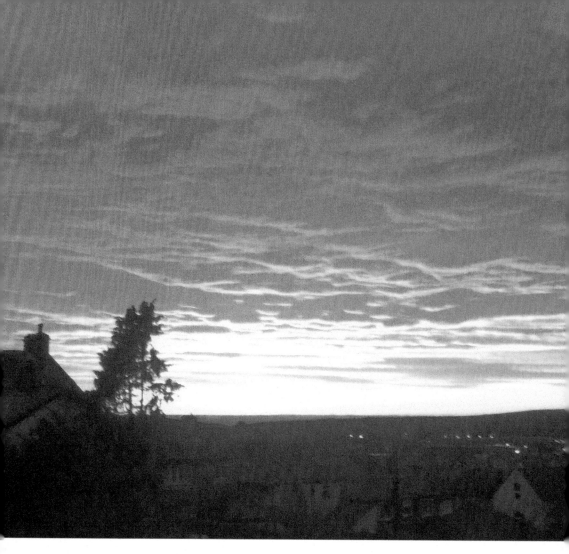

'To sleep on the Solway is to wake in the next world', Sir Walter Scott.

First published 2014

Amberley Publishing
The Hill, Stroud, Gloucestershire, GL5 4EP
www.amberley-books.com

Copyright © H. C. Ivison, 2014

The right of H. C. Ivison to be identified as the Author
of this work has been asserted in accordance with the
Copyrights, Designs and Patents Act 1988.

ISBN 978 1 4456 2180 7 (print)
ISBN 978 1 4456 2195 1 (ebook)

British Library Cataloguing in Publication Data.
A catalogue record for this book is available from the
British Library.

Typesetting by Amberley Publishing.
Printed in Great Britain.

Contents

Acknowledgements

I wish to record my thanks to friends and fellow researchers, many who are named within this book, and others who wish to remain. Thank you for your input, generosity and knowledge: Mr D. Woodruff; Mr J. Wilson; Mr E. Ivison; Dr P. K. Ivison; Mr J. Lancaster; Mr I. Cuthall; Mr H. Martin; Mr M. Coupe; Mr D. Powell; Mr M. Tognarrelli; Mr P. Corckhill; Mr Vollers; Mr T. Thompson; Mr P. Renac Joan MacDowall; Jane Laskey and Irene Lowden of The Roman Senhouse Museum; staff of Workington Library; staff of Kirkcudbright Library; Steve Johnson, editor at the *Times and Star*; and a very special acknowledgment and thanks to Workington RNLI.

Sunset on the Solway Coast.

The Solway Firth, 'that most beautiful and dangerous of seas', isn't strictly a sea – as most people will know. It is a firth, or frith, to use the older version. The meaning of firth/frith is well known, commonly referring to a narrow inlet of sea. The meaning of 'Solway' appears obvious – or does it? This inlet of the Irish Sea, renowned for glorious sunsets, when the surface of the sea can look like a sheet of gold, combines 'Sol' and 'way' to become 'the Suns Way' or 'Path of the Sun'. Obvious? Not quite.

When I was at school, I remember being told that 'Solway' meant 'muddy puddle' or 'crossing', which I found somewhat unromantic. However, research the name Solway and you begin to come up with some interesting answers. Sedgefield's *The Place Names of Cumberland and Westmorland* (1915) gives 'Sulewad' (P. R. 1228; Pat. R., 1218), and states that the Solway is often derived from the Old Norse *Sol-vagr*, meaning 'muddy bay'. Upon further investigation, we realise that in the earlier form it could mean 'ford'.

It is hardly surprising to find the Norse involved in naming the Solway, as you only need to look at local place names to show how strong the Scandinavian presence and influence was in the area. What is surprising, however, is that although the Romans also had a strong military and domestic presence on these shores, they do not appear to have had a name for the Solway – or at least none has been found or identified. I find this fascinating, and it is far from the only unusual or intriguing thing that it is possible to find when looking closely at this beautiful coastline.

It is sometimes a matter of debate as to exactly where the Solway starts and finishes. In general, St Bees Head, with its ancient priory church nestled close by, on the English side, and the Isle of Whithorn, with its equally ancient and famous priory on the Scottish shore, are the points most often accepted as marking the mouth of the Solway. Despite this, in Scotland's case, I think that Burrow head would be more geographically, if not so traditionally, accurate.

The presence of many other ancient and world-famous sites around the Solway shore says a great deal about this area's importance and

history. The Solway lies at the heart of the old Northern Lands, and around its coastline there is evidence of occupation and industry from prehistory to the present day.

A fertile sea within close proximity of productive lands, it has seen its share of occupation and conflict. The Debatable and Border Lands cross the head of the Firth, and other parts of its shores were 'significant' during the First and Second World Wars.

A designated Area of Outstanding Natural Beauty, the heritage of the Solway has been long in the making and is still growing. As well as evidence of Romans, Vikings, saints, reivers and freebooters, there are tales of fishermen, lifeboat men, mining, famous (and infamous) visitors, murder, ghosts, folk tales, wonderful flora, wildlife and much more – including, perhaps surprisingly, UFOs.

In short, the shores of the Solway Firth and its immediate hinterlands cover everything from state-of-the-art technology to cup and ring stones. There is so much of interest that it has been more than difficult to decide what to include and what to leave out. My decision was to follow the coastline, with some interesting detours, and I do hope that I will be forgiven for omissions.

St Bees to Maryport

St Bees, Bega, St Bees Head, Whitehaven, Moresby, Spirit, The Lowca Bombardment, Harrington, Salterbeck, Mossbay, Workington, Lifeboats, Siddick, Flimby, Fothergills, Grasslott

St Bees

Anyone who has studied the lives of the Northern saints will readily recognise many of the names and places around the Solway coast. These and the abundance of stone crosses are just two examples of the many markers that can give clues to the spread and pathways of early Christianity across the North West.

Religion has had a great and long-standing influence within the area. I think that it can sometimes be difficult to envisage the power and wealth of the early Church or the awe, and sometimes fear, in which it was held. For many, the priests must have appeared to hold the promise of salvation or damnation, a terrifying thought for a mostly uneducated population.

In the past, sea routes were generally regarded as the most convenient and often the safest, way to travel. The route from Ireland to the north-west coast of Britain has the reputation of being a much used and ancient way, with Ireland to Whithorn, Whithorn to the Cumbrian coast, overland to Whitby and other influential religious sites regarded as a 'common enough' journey.

There are many similar routes embedded in the local heritage and folklore. It has often been commented that at one time the Solway appeared 'thrang', with priests and smugglers almost outnumbering fisherman. As many of the local fisherman were more than probably smugglers (on the side), it could well be a reasonably accurate assessment of the seagoing traffic of the time. Add the Isle of Man to Ireland, Whithorn and Cumbria and you have one of the most active and infamous of the old smuggling areas.

St Bees Head to Ramsey is less than 40 miles, the point of Ayre to Whithorn is 17–18 miles, and Peel to Belfast less than 70 miles (Ramsey, Ayre and Peel are all on the Isle of Man).

There is no single main road skirting the Solway, and the best advice I was ever given when exploring this fascinating coastline was to 'have a good accurate map and an open mind'. There are many unexpected treasures to be found in the winding side roads.

The B5345, which leaves the A595 between Calder Bridge and Egremont to descend towards the coast, is one relatively direct route to St Bees. The OS map will show a number of others, all with varying degrees of steepness.

The village of St Bees boasts at least a thousand years of history, probably more. The excellent leaflet promoting both this village and surrounding area mentions the Norman Priory, which, in common with so many others, suffered under Henry VIII, and the Elizabethan School, founded by Edmund Grindal, who was born in the village and became Archbishop of York and Canterbury. St Bees School is now a co-educational public school.

The priory church survived the Reformation. It is still the parish church and well worth a visit. It was during an archaeological dig at the priory in 1981 that the mummified body of a man was found in a lead coffin. Known as the 'St Bees Man', this body's unusually good state of preservation (described as 'unique') was such that a modern autopsy was carried out. At present, it is thought possible that the body could be that of Anthony de Lucy, who was believed to have died or been killed in the Crusades.

The origins of the name St Bees, according to Sedgefield's *Place Names of Cumberland and Westmorland,* are Sancte Bege (twelfth century) and Begekirk (1358). The volume offers even more spellings for Bega, Begha and Begu, and comments on W. G. Collingwood's opinion that St Bees was an established sacred site long before being adopted by Irish/Viking settlers.

There are many opinions on the age and origin of the site, including speculation that it could be pre-Roman. There are also a number of theories as to how this place name originated, all of which agree, at least in part. The simplest version states that the site of what was eventually to become the priory was originally occupied by a hermit with a reputation for healing (whether male or female is a little hazy) and that St Bees is a version of this healer's name. The date associated with this story is usually given as 'around seven/eight hundred'.

Possibly the best-known and certainly the most romantic story associated with the naming of St Bees is the story of St Bega. There are variants of this legend, but considering its age it is remarkably consistent. It is interesting to note that Sedgefield appears to agree with 'Santa Bega'.

Bega

Bega was a young Irish princess who fled her home and country rather than endure a forced marriage to a Viking overlord. We are told that she took to sea in a coriacle and was caught in one of the infamous Solway storms, eventually being cast ashore, unscathed, in the area that was to become St Bees.

How the girl survived this crossing is one of a number of miracles associated with her life. In thanks for her deliverance, it is said, she founded an order of nuns who became renowned for their healing skills. That's the basic, simple version, but there are many more details and associated tales concerning Bega, most famously that of her magical healing ring. This silver ring, probably an amulet, was said to reside within the priory church as late as the twelfth century.

The young princess's arrival is given the possible date of AD 6500–6800, though there is often debate as to whether she was pre- or post Viking. By AD 1100–1200, Bega had become a Christianised canonised saint named Bridget. Some postulate that Bega's fleeing to this part of the coast was deliberate, and that the young princess deliberately came to seek refuge with an established order of sisters, who revered Bridget (or Bride) as an ancient mother goddess of Ireland.

We read that the Irish bride was associated with wedding celebrations and blessings well into the twentieth century, having specific association with woman and children and being protective in childbirth. This St Bride also had an old tradition of silver amulets bearing a cross and/or a version of her name; these amulets were regarded as protective. This tradition of a protective silver amulet seems intriguing when viewed alongside the Bega legend.

Within Cumbria there is St Bride, St Brigit (various spellings), Brig and Brighida; it is interesting to note that the legends of all share some commonality with Bega. Bega is a big subject, intricately interwoven into local folklore and heritage, and she makes a fascinating and somewhat complicated study.

There is an evocative bronze statue of Bega in her coriacle by local sculptor Colin Telfer, this stands in the memorial garden near St Bees railway station. The first trains ran from the village in 1848.

St Bees Head

The English and the Scottish shores of the Solway are remarkably and wonderfully different in appearance. To view this contrast from the water is a sight indeed. With the high moors of Cumbria, the hills of the Lake District and Scotland's mountain ranges form a stunning

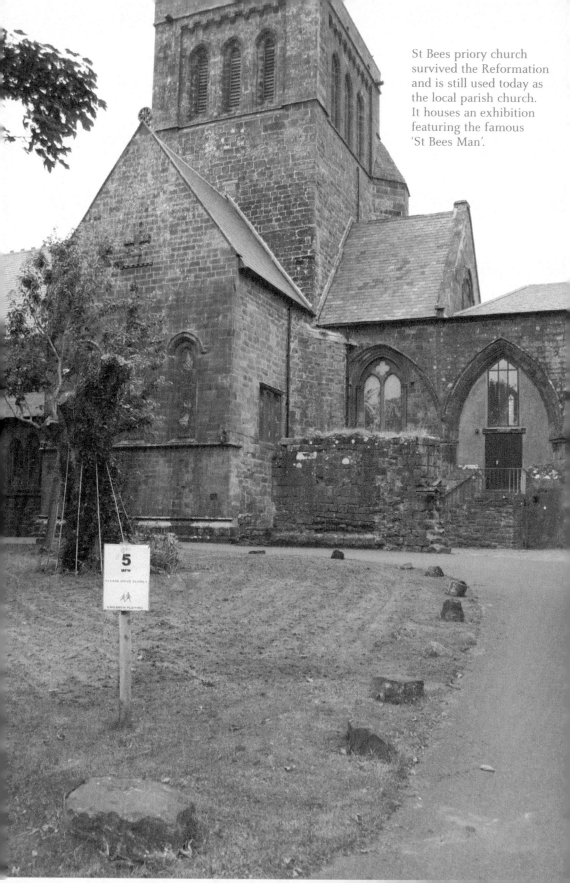

St Bees priory church survived the Reformation and is still used today as the local parish church. It houses an exhibition featuring the famous 'St Bees Man'.

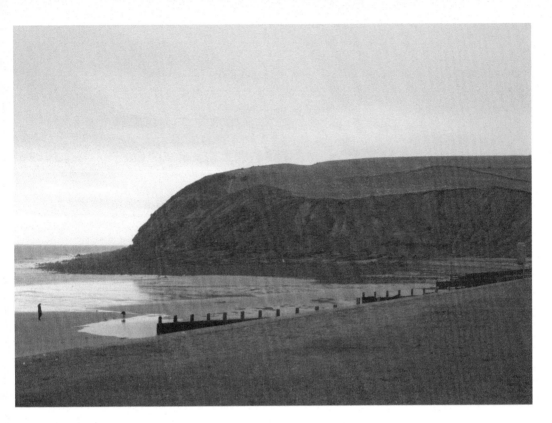

The famous St Bees Head.

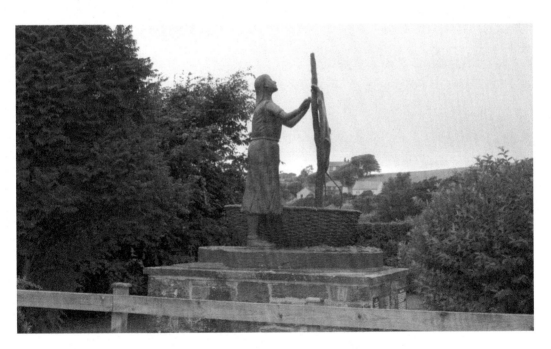

St Bega the Bronze, by local sculptor Colin Telfer.

panorama to the superb rugged cliffs and bays of Galloway, the sandy 'heads' and crumbling cliffs that overlook the ever-moving dunes of the Cumbrian shoreline, and the marshes of the infamous and lovely 'debatable lands' that lie across the head of the Solway.

Sadly, the clear weather that enables a full panoramic view of the entire Solway coast is all too rare, but as anyone familiar with the area will know, the infamous and inclement changes of Solway weather can also look fantastic. Watching cloud banks scud across the surface of a steely sea, or seeing a squall appear from apparently nowhere, are sights not to be forgotten. Either or both are sights better viewed from land than sea, as this remarkable body of water can be dangerous and commands respect.

Solway storms and cloud banks are said to have defeated Julius Caesar twice when he attempted to land 'somewhere' on the Cumbrian shoreline. Exactly where has always been debatable. Legend tells us that the particular cloud banks and inclement seas that defeated him were caused by storms spun by Northern Wise Women; this tale is given a date around 6 BC. Whatever the truth in this (and other) tales, when the Romans eventually arrived on these shores it was by a somewhat different, land-based route.

St Bees Head consists of a north and south head and is over 300 feet high in places. Given its prominence and the sheltered beach that lies in the lee of the south head, it is surprising that there are (thus far) no signs of Roman occupation in the immediate area. There are many traces of such occupation both upcoast and downcoast of the head, and evidence of Iron Age occupation close by. It does seem odd that the Romans ignored what is, to say the least, a wonderful lookout point. However, the head is sandstone, so it is possible that any remains have long since disappeared into the sea.

There is a wonderful apocryphal story of disappearing remains, although the sea was not involved in this particular tale. It is said that not so long ago, standing stones and a stone circle were still to be seen on St Bees Head. Local people, getting somewhat fed up of their land being trampled over by visitors wishing to view these monuments, dug pits, pulled over the stones and buried them. Pulling over even relatively large stones would not be such an impossible task if you had sufficient men, chains and horses.

The cliffs of St Bees Head are justly famous for their seabird colony. As a Site of Special Scientific Interest, it is one of the largest colonies of seabirds on England's west coast. An RSPB reserve names the main breeding sea birds as guillemots, puffins, auks and razorbills. Herring gulls, fulmars, kittiwakes and shags also breed here, and the black guillemot is the reserve's speciality.

Many other species have been and are recorded at the reserve, including fifteen species of butterfly.

The beach that lies in the lee of the South Head is mainly shingle, with wide bands of sand uncovered at low tide. Shillies, gravel and sand were collected here commercially as late as the 1940s. As well as such utilitarian use, this beach was, and remains, a source of leisure and pleasure for visitors and locals alike.

Wainwright's famous Coast to Coast walk begins or ends (depending on your inclination) here. Wainright himself said that it should go from west to east, or left to right – the same direction as writing. There is a fine sign showing the route from St Bees to Robin Hood Bay, situated close to the RNLI station, where the inshore rescue boat is stationed.

The Cumbrian Coastal Way is another famous walk that features this area, taking in both beach and head. The route passes close to the famous St Bees Lighthouse, built in 1718, and this aid to shipping has a 17-metre tower and was coal burning until 1822.

Heading upcoast towards Whitehaven, the Coastal Way walk passes close by Fleswick Bay, situated down coast of the northern head. This steep inlet was renowned as a smugglers' haunt. The pebble beds of Fleswick contain semi-precious stones, but finds are rare. At least one guide to the Coastal Way comes with a timely warning against following the shoreline

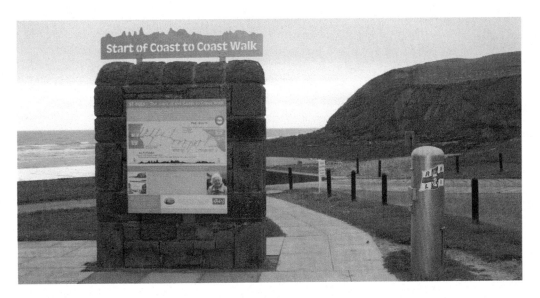

Above: Whether this sign marks the beginning or end of the Coast to Coast walk is often a matter of debate.

Overleaf: Fleswick Bay, a famous 'smugglers' cove'.

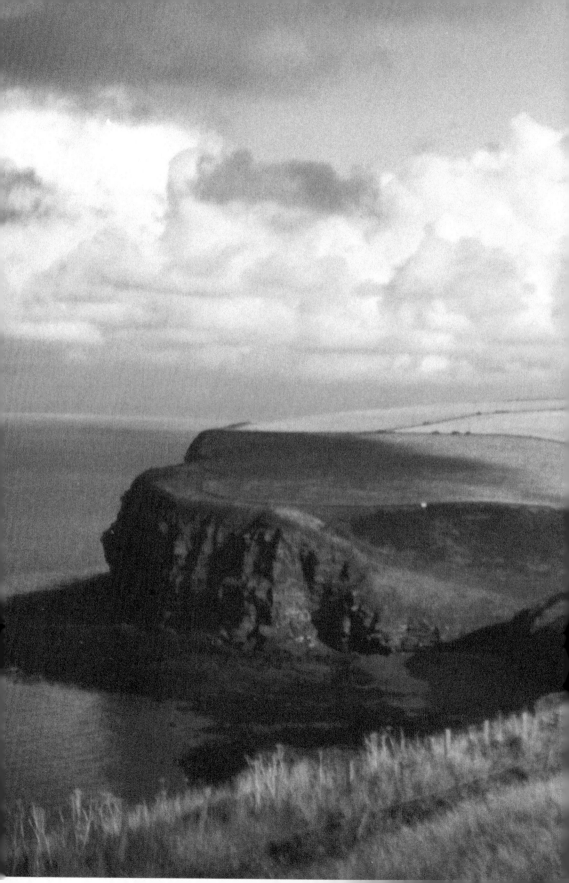

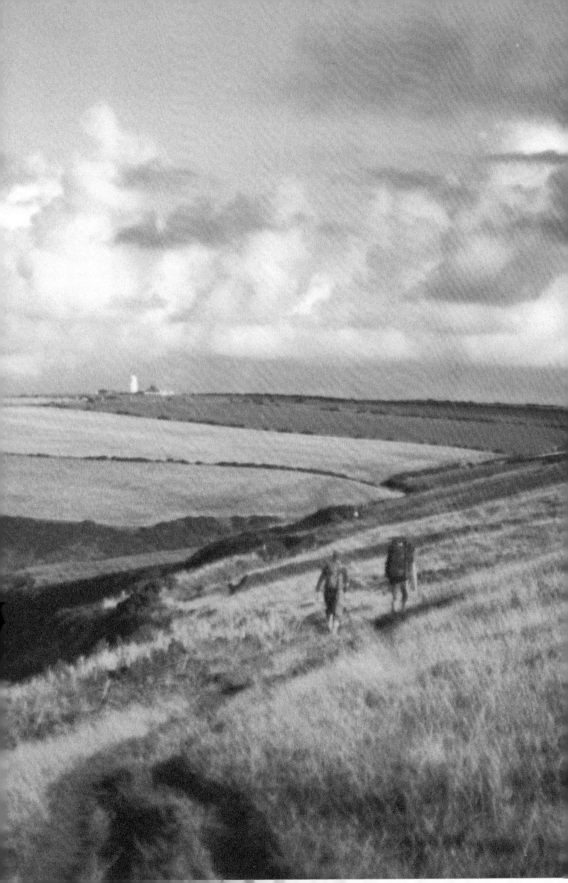

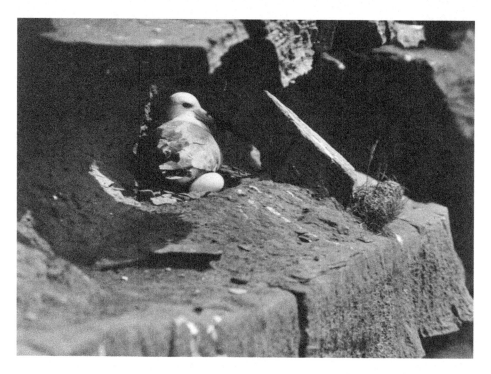

These are among the first photographs to be taken of fulmars nesting on the cliffs on St Bees Head. Previously, there was some debate as to whether these beautiful birds actually nested and bred on the Head. (*Photographs by the late A. Barton, climber and photographer; with the permission of his heirs*)

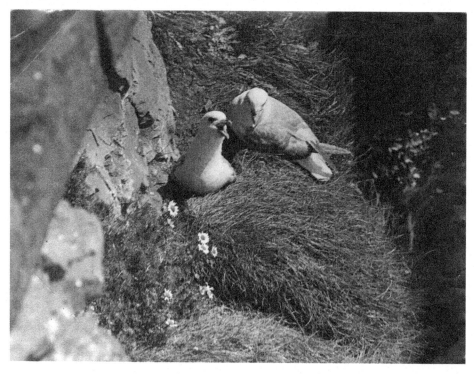

between Fleswick and the Head north or south, or for several miles in either direction. It's a serious warning; there is no escape from the tide here, and the Solway tides and currents are fast and dangerous.

The cliffs, hinterlands and shoreline around and above the Firth, as is common in areas that have seen human use and occupation for millennia, are criss-crossed with old and new pathways, byways and trods. Many people will be familiar with the term 'colliers trod', and the ghost stories that go with them. The lives of working people who wrenched a living from the sea and earth, especially in the past, were brutal and short. Sometimes their superstitions tell us as much of them as the history books.

The lines of many of these traditional foot trods have now been incorporated into the modern paths and trails, which are well mapped and maintained. North of St Bees (if you know where to look), it is possible to recognise the lines of some of these old pathways, many of which have seen generations of miners and other workers' feet. The West Cumbrian coast has a long history of industry, one of the most famous (or infamous) being 'King Coal'.

The coast from Whitehaven to Maryport is rich in sea coal, and some Solway towns and families expanded and grew rich on its bounty.

Whitehaven

Whitehaven is one such town, and the Lowthers one such family. The Lowthers, and other principal families, did, of course, have other sources of income, but coal was a reliable and solid base of wealth. Whitehaven's main coal trade was developed by successive generations of this family from around 1630. Over time, however, the collieries were leased to a number of private companies.

Monks from the Priory of St Bees appear to be the first users of Whitehaven as a designated port, to which they had exclusive rights, which were possibly put in place soon after the foundation of the priory in 1125. The brothers also controlled several salt pans along this part of the coast, and according to one charter, coal appears to have been mined at Arrowthwaite as early as the thirteenth century. Around the same time, and possibly earlier, the area seems to have been a somewhat scattered rural community, similar to many others spread around and above the coast on both sides of the border.

This port's sheltered bay is thought to derive its name from old Norse, and could mean 'Haven by the White Head'. There is said to have been an alabaster outcrop in the area; this mineral has long disappeared.

Whitehaven as we see it today is a mainly well-preserved Georgian town, which expanded and grew alongside its port and shipyards.

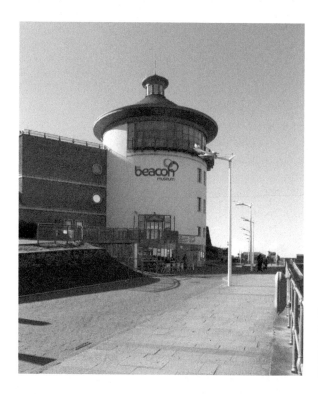

Whitehaven's newly refurbished Beacon Museum.

Sir John Lowther (1642–1705) is credited as the original driving force behind this expansion. Within his lifetime, an 'insignificant little village' grew into an important town. Other towns on both sides of the Solway saw the beginning of a rise in prosperity and expansion of their ports within the Georgian era. The Port of Whitehaven was to eventually become the third busiest in Britain, both receiving and shipping cargoes to and from all corners of the world.

There is sometimes debate as to whether or not slaves were shipped to or through Whitehaven. A slave ship called the *Black Prince* was built here in 1754, but I personally have never seen anything to tie this port with the shipping of slaves.

A seemingly little remembered export of the port was stone. Stone was shipped from here to be used in the building of St George's chapel, Windsor, between 1154 and 1189. Sandstone was also exported from Whitehaven to be used in building the Washington family home in Virginia, and that is not the town's only tie.

One George Gale, the son of one of the town's leading families, visited Virginia, and there he met and fell in love with Mildred Warner Washington, a young widow with three children. After their marriage, they took up residence in Whitehaven. Tragically, Mildred died here after the birth of a daughter, within a year of the union.

A dispute over Mildred Washington's will saw her sons, Augustine and John, returned to America in 1704. In 1732, Augustine became the

father of George Washington, first president of the United States. How different history could have been!

Another of Whitehaven's American connections is its brush with the American War of Independence, when the harbour was raided by John Paul Jones. Many people will know or have heard something of this raid and, over the years, he has become regarded as a somewhat romantic figure.

Born at Kirkbean, just across the Solway, in 1747, the fourth of seven children, John Paul served his apprenticeship in Whitehaven before emigrating to America and joining the navy ('Jones' was added to his name in 1773).

It was as John Paul Jones, the Commander of an American ship, the *Ranger*, that he returned to the port in April 1778 with a good working knowledge of the coast, harbour and possible fortifications. His target was a large fleet of merchant vessels sheltering there.

A party consisting of Jones, with some officers and men, landed and captured a small fort, spiking the cannon. But the following party intending to burn the ships 'were frightened by certain noise' and returned to the *Ranger*.

Some local stories tell of a collier (boat) and a house being set alight, and also of a seaman deserting and warning the town. There are also tales of foul weather, making it almost impossible for anything to burn! It sounds altogether a somewhat unsuccessful attempt at American domination. The raid is remembered in periodic re-enactments of the event.

Whitehaven harbour and shipyards, in common with others in the area, declined with the change from sail to steam. Now the town boasts a beautifully landscaped seafront and marina. Dominated by The Beacon museum, it is to The Beacon that I owe thanks for much of my historical information in regard to Whitehaven, with a special thank you to Les Donnon for his corporation and help in my archive search.

Looking upcoast from The Beacon, you get an excellent view and impression of the height of the cliffs that overlook the shoreline here. An interesting way to see this part of the coast and its cliffs is from the train. The journey from St Bees to Maryport, where this line cuts inland, is one of the best places from which to observe these bastions decrease in height. Also, the views across to Galloway can be spectacular and, depending on the light, a little weird. It is possible for the sea to appear so flat and silvered that the opposite shore could almost be a mirage.

Another added bonus to this rail journey, a bonus that does depend on the time of year and our increasingly capricious weather, can be one of the best displays of wild primroses in the area. The flowers seem to love the west-facing sandy banks.

The A595 passes through the outskirts of Whitehaven, just upcoast of the town, and the village of Morosby stretches either side of this main road. This is not simply a caprice of the new bypass, the old road, and possibly the original throughway divides the village.

Moresby

The name of the village is based on a personal name: Morris. Other than progressing through various forms of spelling since the twelfth and thirteenth centuries, Sedgefield has little to say about it. There was a Roman fort at Moresby called *Gabrosentum*; it occupied the land between what is now the churchyard and the clifftop, an area known as Croft Field, overlooked by the ruins of the old church. Both the old church and its replacement can be seen from the road, high on their mound in spectacular silhouette.

The 'new' church, which was built in 1882, sits happily alongside the ruins of its predecessor. Each compliments the other and both are named for St Bridget. A probable date for the earlier building is given as 1292.

Local folklore and legends tell us that there is an ancient holy well somewhere in this area. Church vaults, a secret passage, swans and (unusual in Cumbria) druids are often woven into this story.

As most people will be aware, it is far from uncommon for churches to be built on existing worship sites, and there has been, and still is, some speculation that this area could have been a worship site for Coventina, a Celtic well goddess. Coventina was adopted by the Romans, and there are a number of sites, proven and unproven, dedicated to this goddess. One accepted proven site lies at Carrawburgh on the Roman wall. There is a great deal of well worship and aligned beliefs in Cumbrian folklore; Rosmerta is often mentioned, and there is a postulated theory that Conventina and Rosmerta are interchangeable – a single deity under differing names.

A common, if perhaps simplistic, saying tells us that folklore is man's collective memory: history is what gets written down. It is fascinating how the generic base of folktales and such vary around the Solway, and it can be possible to see links between the geography of an area and the types of tale common there. Generic entities are very often location specific.

Tales of 'Spirit' are relatively common in the mining folklore in other areas of Britain, but only in west Cumbria does she have the alternative title of 'The Lady', a title that has been associated with female deities – interesting within an area that has traditional ties to Bega/Brigit.

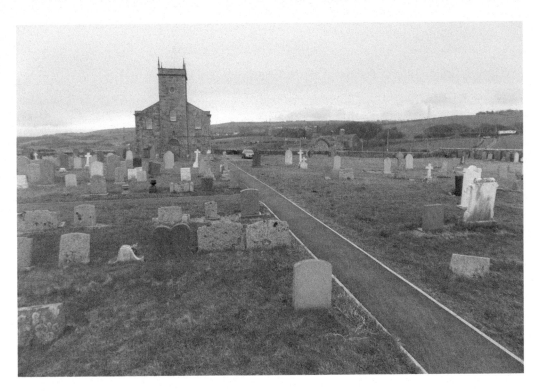

Moresby church and the remains of the 'old' church. This is supposedly the site of a secret passage and magical well.

Spirit

Spirit is said to take the souls of children. The little ones would be found curled up in the galleries, rosy cheeked and smiling in death. The lives these little ones must have led are almost beyond imagination in their horror.

Spirit is regarded as a wraith (unlike a ghost, a wraith has never existed in mortal form), and her appearance is that of a lady with long, blond hair, clothed in trailing, floating, white. This entity also exudes a smell of violets or roses. She haunts the deepest, dankest galleries of the mines. It is said that 'grown men can 'scape her, but she takes the souls of bairns'.

There is indication of some truth behind this. Some years ago, while doing some research, I was privileged to be told a very personal tale. The gentleman I spoke to told me that, between the wars, he and his brother had been caught up in a local mining accident. He got out relatively quickly, while his brother, being in a lower gallery, was carried out some time later. His brother swore that he had seen Spirit.

I am aware that in describing Spirit I could be describing the effect of that most insidious of killers, gas. Also, what an adult could survive would probably kill a child. Yet the story of Spirit, of seeing a specific entity, is as widespread and as old as mining itself.

An interesting footnote, in the North West, you are told 'not to follow the lady' as she leads to death. In some other areas, they say 'follow the lady', as she leads to fresh air and freedom.

Moresby, Parton and Lowca, are situated between the ports of Whitehaven and Harrington, and looking through series of old maps it is fascinating to see how this stretch of coast grew from a largely rural area to closely packed clusters of houses associated with mining and connected industries. Although there still is rural land and farms, by the early part of the twentieth century, Parton, Moresby and Lowca, were virtually surrounded by industries, including the Harrington coke and by-product works situated at Lowca.

This works had fifty coke ovens that were started in 1911, and another fifty were added in 1913. The ovens were for the recovery of by-products, tar, ammonia and Benzol. This top-secret plant was one of the few British plants to be producing synthetic Toluene (an essential constituent of TNT) from Benzol.

The Lowca Bombardment

On Monday 15 August at 4.50 a.m., Harrington harbourmaster Capt. Cowley and his deputy, Capt. Robert Moore, were out in two boats enjoying some early morning fishing (they had been out since 3 a.m.) when a U24 (a 240-foot German submarine) surfaced some 400

yards from their small craft. Moving swiftly, the grey hulk fired a first ranging shot from Parton Bay. The two captains (not surprisingly) headed for Harrington Harbour as fast as their arms could row. Local legend says that Capt. Moore made it first and that there was steam coming from the bottom of his boat. He quickly alerted the authorities, including the naval base at Walney, Barrow-in-Furness.

Fifty-five shells were fired in fifty-five minutes. Miraculously, only four did any real damage, but there were holes in two of the 11,000-gallon Naphtha tanks, a 50-gallon drum of Benzol was set ablaze and the powerhouse that received a hit from a 'dud' shell sustained a hole in its chimney. Some 900 windows were also broken.

After the first well directed shots, the gunner's aim appears to have deteriorated, as shells flew around Low Moresby, Parton and Harrington No. 10 Colliery. There was some local damage, but thankfully, or miraculously, no one was hurt, with the exception of a dog. Some colliers were undoubtedly saved by Hodgson Twentyman, the stationmaster at Parton who held back their train, preventing it from running through the barrage.

Oscar Ohlson, the engineer on duty with Dan Thompson, his valve man, remained on the plant throughout the bombardment, and together they carried out the well-rehearsed wartime procedures that were in force at the works. These contingency plans consisted of certain steam traps and valves being fully opened, and six blasts on the steam whistle as warning to the local population to flee. It was later concluded that the effect of these actions (flames and gas, dense yellow smoke plus the Benzol fire) probably convinced the U-boat captain that his attack had been successful.

My sincere thanks are due to Jeff Wilson, writer and local historian, for access to and permission to use information contained in his excellent paper on the bombardment of Lowca.

The bombardment was seen and heard along the coast, and Jeff tells us that spectators crowded onto Whitehaven's many piers for a better view.

Accustomed to driving as we have become, it is easy to forget just how relatively close (as the crow flies) some these coastal towns and villages are to each other.

The B83 goes through Lowca, but for those not familiar with the side roads, the A595 then A597 is the simplest way upcoast. This route takes in Harrington and Workington, from where it is possible to follow good costal roads as far as Silloth and Skinburness.

Geographically, from Whitehaven to Maryport has been one of the most industrialised and productive parts of the Solway. Coal, iron, stone, bricks, aggregates and munitions are just some of the products produced and shipped.

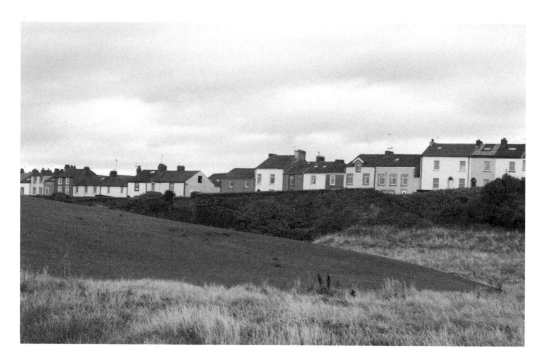

Georgian houses sit on the ridge above Harrington shore. The grass in the foreground covers the site of the old village.

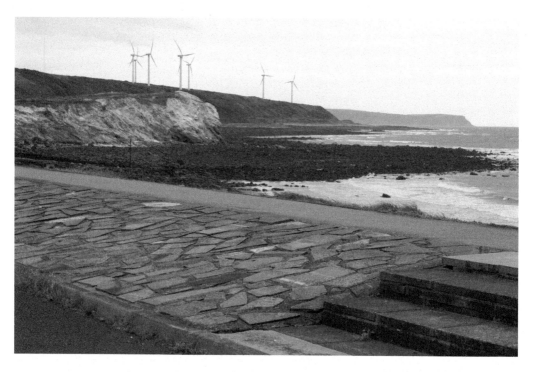

Looking downcoast from Harrington shore, towards Parton and Lowca. Chunks of slag and other remnants of industry lie on the beach.

Harrington was (and still is) a baronetcy, which gives some clues as to its age. This western coast is fertile and productive land and the French Normans were much in evidence, as their castles and church architecture show.

The seafront and harbour are well landscaped and a popular place to walk. The harbour is now a busy marina, and grassy banks and a playground cover the footprint of the terraced rows that stood here until well into the twentieth century. The main part of the village snakes up the hill to the moor top, and boasts many fine Georgian houses as well as modern expansion.

From Harrington's pebble beach, there are clear views for some miles, both upcoast toward Workington and downcoast to the jutting headlands around Whitehaven. The industrial scars and what has been done to expiate at least some of them are visible for some distance. This is one of the places where sea coal was gathered in the dark days of the 1930s, and possibly long before. Here, as on other Cumbrian shorelines, large chunks of slag speak of the past. In common with its neighbouring ports, Harrington too prospered on shipbuilding and industry.

At one point, there were eighteen pits in the Harrington area. It is quoted that these pits belonged to the Curwens, a family with Norman roots, owners of Workington Hall and a principal family within the area. There is a history of rivalry between the Curwens of Workington and the Lowthers of Whitehaven, a rivalry that lasted for some generations, although, as in most such things, the more interesting stories are probably mainly apocryphal.

The coastal villages of Salterbeck and Mossbay lie between Harrington and Workington. I say villages, but while they each still retain their own identities, Harrington, Salterbeck, Mossbay and Workington have been physically joined for some years. The shared industries of iron, steel and coal spilled along the shoreline.

Salterbeck

There is said to be a 'Shore Boggle' at Salterbeck. This shaggy, long-haired creature is described as having vicious nails and bright, red eyes; these entities are location specific and always associated with old smuggling tracks and haunts. They are known as far downcoast as Morcombe Bay.

The last recorded sighting of Salterbecks boggle was as late as the 1930s, when a man was viciously attacked while walking home along the shore after a late shift. The victim needed hospital treatment, and was in no doubt as to what he had seen. He was ready to go into print on the subject.

From Salterbeck shore, you get an excellent view of the re-contoured and landscaped slag banks of Moss Bay and Workington. It is difficult

Winter survivors.

to define which were the old Shore Hills and which were slag bank, but the views are wonderful and the created walks popular, with a good panoramic map on the highest point.

Mossbay

The name Mossbay is synonymous with steelmaking, and steelmaking and rails are synonymous with Workington. Workington rails were world famous, and at one period were exported to every country in the world.

Workington's Mossbay works covered the complete process of steel making. Iron ore came in via Workington docks, and steel was shipped out by road and rail.

Mossbay was an integrated plant with blast furnaces and coke ovens on site. There was also an arc furnace, and this works had the distinction of having one of the first and last working Bessemer Converters in the country. The plant was run down gradually in the twentieth century before finally closing.

It was Workington's deep-water port and ready supply of coal that attracted the steelmakers. I have seen an old list of over thirty-nine pits that have existed within the Workington area at one time or another.

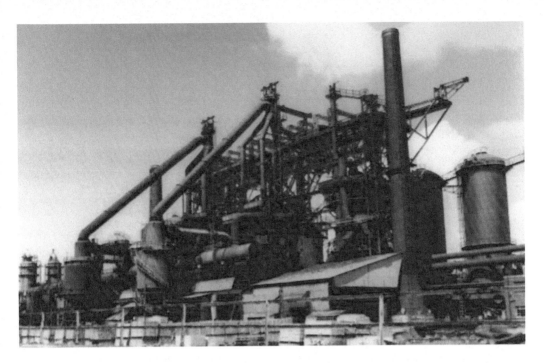

Rare colour pictures of Workington's iron and steel industry. (*Courtesy of Mr Jack Lancaster*)

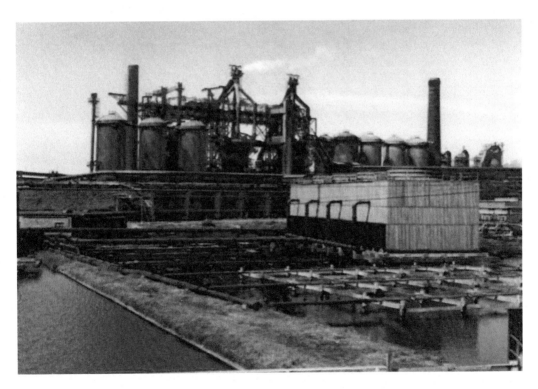

Workington was a world leader, exporting rails to countries across the globe, including Russia. (*Courtesy of Mr Jack Lancaster*)

Workington

Whitehaven and Maryport are both planned towns. The root of Workington's name is most likely Norse, but there is evidence of much earlier settlement and smelting, especially along the riverbanks, for Workington sits at the mouth of the River Derwent, a major waterway and one of the fastest rivers in Europe.

The remnants of a Roman fort, 'Burrow Walls' (the Roman name *Magis?* has a question mark beside it on the Roman OS map of Britain) stands above the river not far from the present coastline. Also, less than a mile downstream of the fort site, a Viking sword was found when the foundations for the stanchions of the original North Side Bridge were being dug in the 1930s. Incidents such as these all add to the evidence of historic settlement within the area.

The Derwent is sometimes called the river of 'saints and sinners' because of its associations with clerics and smugglers. St Cuthbert is one of the saints who has a strong connection with the river, and also with the ancient site on which St Michael's church now stands.

St Michael's is probably the third or fourth church to have occupied this site. This possibility has been confirmed by archaeological exploration in the aftermath of a devastating fire in 1994. This fire was not the first within this building's history and, consequently, there have been several rebuilds. The present building has a superb, modern interior within a mainly Georgian shell, and its fine Norman tower (which has thankfully survived) can be seen from Workington Harbour.

I have been fortunate enough to stand on St Michael's tower, and from this vantage point you get a perspective of just how close to the sea the church mound is. This mound, and its successive occupying places of worship, was said to have a water gate, a 'priest's gate'. Looking at old maps and tidal streams, a water gate looks both practical and possible.

Take away the modern viaduct (built to accommodate the railway line) and the church mound looks directly down onto the inlet where the River Derwent sweeps into the sea. This proximity surely gives an even stronger possibility of truth to the legend that Workington was the place where 'St Cuthbert's body sought the sea'.

Workington appears on the Bodleian map, and also has its place in written recorded history. On 16 May 1568, Mary, Queen of Scots, sought refuge with the Curwens of Workington Hall, having fled across the Solway from Dundrennan.

I have always been somewhat puzzled by how few historians even mention Queen Mary's association with Workington. It was in Workington Hall that the young queen spent what was literally to be her last night of freedom, and it was here that she wrote what was

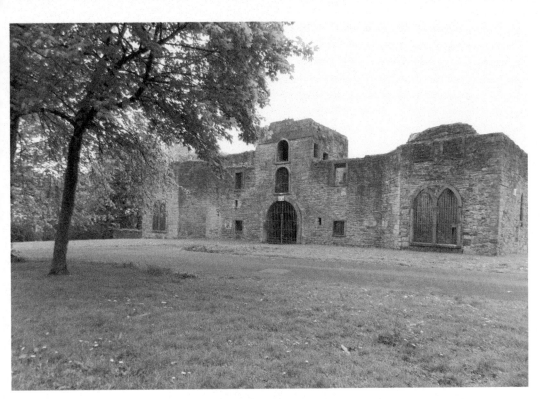

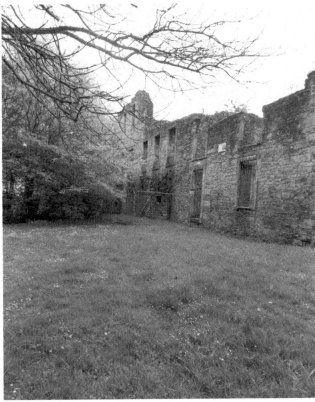

Above: Workington Hall, the scene of Mary, Queen of Scots' last night of freedom.

Right: The three upper windows were the queen's bedroom. The ten Lady Curwen vacated her chambers for Mary.

possibly one of the most famous letters of English history, requesting help from her cousin Queen Elizabeth – a request that was ignored.

Lord Lowther escorted Mary from Workington under protective custody, as history tells us she was taken first to Cockermouth and then to Carlisle. When in Carlisle, how must she have felt to be in sight of the country from which she had barely escaped with her life?

With the exception of a few days she spent as a fugitive, Workington was the beginning of her lifelong imprisonment.

The legends of Workington Hall and some of its more infamous owners and occupants would practically fill a book; one tells of a tunnel between the hall and harbour that has been associated with smuggling and various other activities.

There is one infamous Curwen, Henry 'Galloper' Curwen, who inherited in the aftermath of the English Civil War. An inveterate womaniser and gambler who almost certainly included smuggling among his many activities, he disappeared in the aftermath of a gun-running incident. However, he reappeared some years later, within a month of a cousin declaringhim dead and with a fortune of gold in his saddlebags, claiming his estate. Thereafter, Henry/Galloper, lived out his life in Workington Hall, and is one of the buildings most famous ghosts. It is said that he was killed by his French mistress and her maid.

Old Workington was virtually two towns: one grouped around Workington Hall, high on the south ridge of the Derwent, and another community gathered around the church, close to the harbour and river mouth. The town's Market Charter was granted by Elizabeth I in 1573, and for some centuries the town had two market places, and a tradition of two markets, high and low. One was near St Michael's church and the other, latterly a covered market, was built across an old Went at the 'top' or 'high' end of town. This arrangement lasted well into the twentieth century.

Like other towns along the Solway Coast, Workington prospered in Georgian times as shipping and ship building expanded. However, it was steel that attracted the major rail links and the investment that was to build central Workington in the 1800s. Steelmaking, sadly, is no more, but Workington has developed into a commercial centre that attracts custom from a wide area.

Unlike some of its neighbours, Workington Harbour had the depth and facility to move successfully from sail to steam. The Lonsdale Dock was built in 1865, then deepened and widened in the 1920s. The Port of Workington has continued its development into a modern, commercial port, situated at the mouth of the River Derwent.

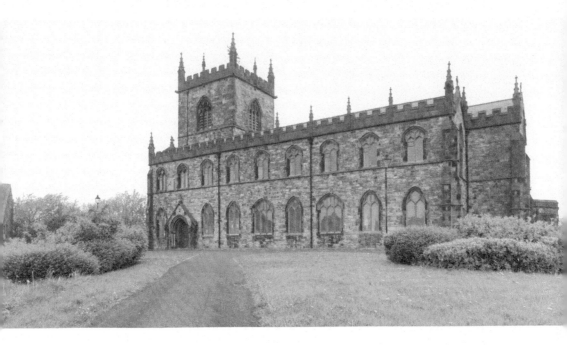

St Michael's church. The water gate is said to have been somewhere around the site of the parish rooms just visible in the left corner of the picture. The land around the church mound has changed a great deal over time. Sometimes, you see 'Priest's Gate' marked on old maps.

Part of Georgian Workington.

Above: Portland Square, Workington: one of the most complete Georgian squares in the North of England.

Left: Workington Harbour: there is both private and commercial fishing from here. St Michael's tower is visible to the right, giving some sense of the present proximity between church and sea. In the past, the water came to the foot of the church mound.

Lifeboats

There are six lifeboat stations around the Solway Firth. Maryport has an independent boat and crew, and the Royal National Lifeboat Institution (RNLI) are responsible for St Bees, Workington, Silloth, Kippford and Kirkcudbright.

Workington RNLI are located on the north side of the river channel. They have both an all-weather boat and an inshore lifeboat, and are unique in their method of launch.

The first lifeboat to be stationed at Workington was the *Dodo* (1886–1899). This craft was the legacy of a Miss Harrison. Succeeding this was the *Theodore and Herbert* (1899–1902). The station closed in 1905. The years 1948 and 1949 saw a number of temporary boats, and then in 1949 a Watson class lifeboat, *The Brothers*, came on station.

Since 1949, there has been a boat permanently on station. The present Workington lifeboat, *Sir John Fisher* (1992), is housed at the north end of the Prince of Wales Dock at the Port of Workington. This boat is a 47-foot, Tyne Class, all-weather boat and is capable of being launched, man-riding, and recovered in any state of tide by a davit type crane, which is unique to Workington, being the only one capable of lifting a boat of this size.

Launch time for the *Sir John Fisher* is 7 minutes when the crew are all on station, and 15 minutes from page. The boat is capable of 17 knots.

Also on station is *The Shannock*, a D-Class inshore lifeboat, which is capable of 25 knots. This boat is due for immediate replacement by an updated version: D767.

Workington's all-weather boat is also to be replaced in 2016, by a brand new Shannon Class, a jet boat (having no propeller) capable of 45 knots

All vessels and the volunteer crews who man them are on constant standby. It is difficult to articulate what their constant guardianship of people, and all manner of craft – commercial and private – means.

For me at least, to be on constant standby with the possibility of your life being in danger defies words. I can only admire.

The northern side of the river mouth is known locally as North or 'Old Side', and saw commercial manufacture before the advent of Mossbay. The road from here to Maryport is still heavily industrialised and, if you know where to look, the surrounding countryside shows traces of long industrial use.

Sir John Fisher and the *Shannock* on Old Shore. (*Courtesy Workington RNLI*)

Sir John Fisher. (*Courtesy Workington RNLI*)

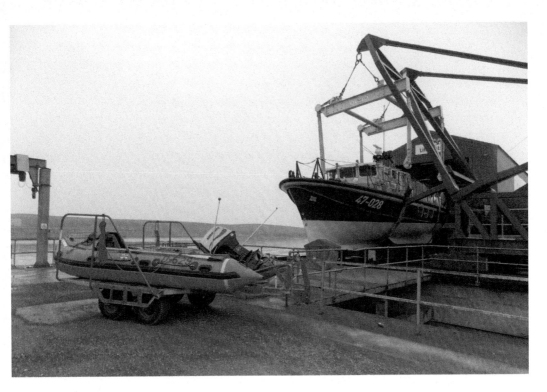

Sir John Fisher and the *Shannock*. The station's unique davit is visible in both pictures. (*Courtesy Workington RNLI*)

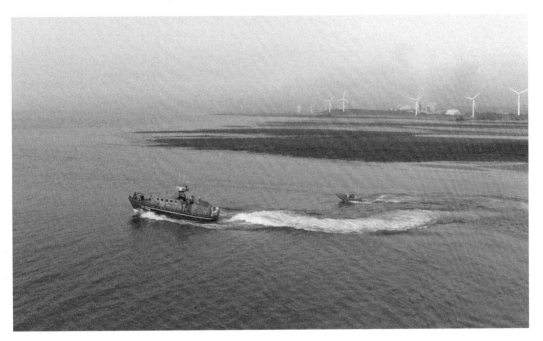

Both boats out on exercise. North Side shore and Siddick are visible in the background. (*Courtesy Workington RNLI*)

Siddick

Siddick means 'sea dyke'. Most of the land here was tidal, washing up to the foot of the Derwent's north ridge, which is known locally as the oyster banks because of the quantities of shells. We are told that oysters were farmed in the Solway in Roman times (possibly earlier), which could say something about our climate.

A legacy of this old tide line is a long-established marsh, part of which is a renowned bird reserve – Siddick Ponds, now under the care and protection of Thames Board Mills. Thames Board is one of the largest industrial complexes on this part of the coast.

Other industries include chemical works and wind farms, and there is barely a break in commercial land between Workington and Maryport. The fields in between are grazed, making this a very productive area.

Early in the last century, the shoreline here, North Side Shore, was popular with locals; it was not too far from Workington for an evening or Sunday stroll. Old photographs show ice cream sellers (penny licks) and deckchairs. For the most part, there is a railway line and embankment between road and beach. The railway line follows close to the coast here and the rail bridge crosses the Derwent near the site of St Helens Colliery at Siddick.

This northern shoreline, which can be approached from an access road leading from the Workington Maryport roundabout on the A596, is still popular, especially with fisherman and dog walkers. It is worth visiting for the views and spectacular lumps of old slag, some of which have begun to look like sculpture.

It is impossible, in the space at my disposal, to name or comment on every village and town around the Firth, but in this particular area a mixture of mining, industry and farming has created long-standing communities that have virtually grown into one long stretch of habitation over the years. They hold a rich and diverse record of local heritage and folklore that spans from ancient iron hearths to modern chemical works and wind farms.

One particular name that I can't leave out is the intriguingly named 'Long and Smalls', a garage since the days when roadside pumps were thought exotic. According to local lore, it was named after the original owners, and was a centre for beach life when it was rare find drinks, crisps and even a small café at such a location.

Flimby is possibly the biggest and probably the oldest settlement. There is a great deal of archaeology in this area, and you never quite know what time and money may find in the future.

Flimby

Flemingeby/Flemingby. It is likely that the area could have belonged to a Flemish landowner. Of all the invaders and settlers of these northern coasts, on both sides of the border, so often we seem to forget the Flemish.

Sedgefield suggests that this 'Fleming' could have been one of the colonists sent to the North by William Rufus after 1092. A look at an OS map gives some idea of the extent of Flimby and includes the famous Flimby Woods. These woods stretch towards Broughton Moor on the moor top and are a fascinating area, but not a place to venture without a guide. They are full of old mine workings and bogey rails and it is very easy to get lost. Also, they are private property. The Fothergills is almost absorbed by Flimby, an unusual and intriguing name.

The Fothergills

What is left of Risehow colliery is near the Fothergills. The shafts are long sealed, but some of the site is still in use; uses include workshops and a new-build ambulance station. Both the Fothergills and Risehow have an interesting Roman connection.

Joseph Robinson of Maryport, a bank manager by profession, and an amateur archaeologist of skill and foresight, found a Roman tower here in the 1880s. He described his find's location as 'Risehow near Maryport'.

In Richard Bellhouse's excellent book, *Joseph Robinson of Maryport*, there is a contemporary description of Robinsons find, which he describes as a 'Roman tower'. Apparently, the evidence came to light during the proposed extensions to the coke ovens at Flimby Colliery.

Not only did the mine owner, a Mr Robert Wilson, postpone the work giving Robinson time to dig, he loaned him a man to help.

The archaeologist Richard Bellhouse was a proponent of the theory that a defensive line of Roman forts, mile forts and watch towers stretched, equidistantly, down the coast of Cumbria, from Wallsend to Ravenglass. The theory is a fort every 5 miles, mile forts at mile intervals between, and two watchtowers between each mile fort. A formidable frontier, which to my present knowledge has not yet been finally proved or disproved.

Bellhouse surveyed and plotted where evidence of such a line might be found. The structure Robinson found at Risehow was right on target for this coastal watch system.

Also in his book on Robinson, Richard Bellhouse mentions a second tower at Risehow Colliery: 'Its twin, 540 yards to the north on the summit of Risehow, was uncovered in 1982.' I presume 'its' twin, refers to Robinson's tower.

When I see accounts of these, and much later finds by many people, it always makes me wonder just what is under houses, roads, gardens, or indeed in the Solway?

The name 'Fothergills' is interesting. There are two 'gills' in the area; I have been unable to find any names. According to the 'Register Flimby', within the time the land hereabouts was owned by Holm Cultram, one of the Flimby boundaries appears to have been a 'Folekgile'.

Grasslot

The name says it all. It tells you part of its history – or at least its beginning. Now a mixture of houses, factories and buildings of varying periods, many of the structures have been built and rebuilt over even older foundations as happens when communities exist for generations.

Grasslot and Maryport have long grown into each other. On the main road into Maryport, as you cross the bridge over the River Ellen, on the left you see a Mott overlooking this river as it bends to join first the harbour and then the Solway. The fine Georgian building, high on the sea brows beside the Mott, is the Maryport Settlement.

Above: The outskirts of Maryport, showing the River Ellen below the Mott and Settlement.

Opposite: Looking towards Maryport's harbours from the Settlement. The River Ellen in visible below.

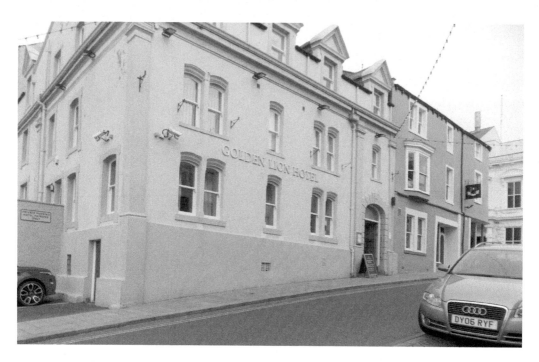

The Golden Lion.

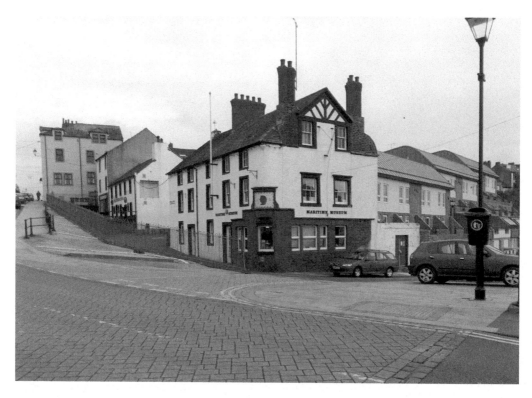

Shipping Brow from the bridge, showing the Maryport Maritime Museum.

Maryport to Port Carlisle

Maryport, River Ellen, The Lake District Coas Aquarium, The Senhouse Roman Museum, Excavations, Saltpans, Allonby, Sea Wives and Boggles, The Red Bank Boggle, The Beck Foot Boggle, Sea Wives, Silloth, Skiburness, The Two Brothers, Campfield Marsh, Ghost Horses, Bowness on Solway

Maryport

This rich and industrialised coast from Whitehaven to Maryport was chiefly in the ownership of families of political weight, the Lowthers (Whitehaven) the Curwens (Workington) and the Senhouses (Maryport) – and there were rivalries.

The Georgian Maryport that we see today, with its wonderful houses and formal grid street plan, was the inspiration of Humphry Senhouse II, a local landowner. In 1749, he procured an Act of Parliament to develop a new town and harbour. His ambition? To rival Whitehaven. He named the town for his wife, Mary Senhouse.

In *Jollie's Cumberland Guide and Directory 1811*, while he has something to say of all three towns in his list of 'Parishes, Chapelries, Town-Ships and Villages', Jollie mentions Whitehaven and Workington, but not Maryport. It makes you wonder, what the ambitious Mr Senhouse's reaction would have been.

Maryport still has her harbours, used for leisure and fishing, and a wonderfully picturesque seafront. The views from some of the houses must be magnificent. The town rises steeply from its harbour and buildings of various periods, many with wide windows, are scattered among the Georgian gems.

One of the oldest buildings in the town is the Royal George. Having gone successfully through a number of extensions and alterations within its history, this fine building dominates the brow above the harbour bridge. Charles Dickens and Wilkie Collins stayed here during their West Cumbrian travels.

Maryport was Ellenborough, or Ellenfoot, or Ellenbank, named after the River Ellen. Distinct local areas still carry these names and have for generations. Which was the original, or the oldest, depends on whom you read. However, most local people agree that the original settlement

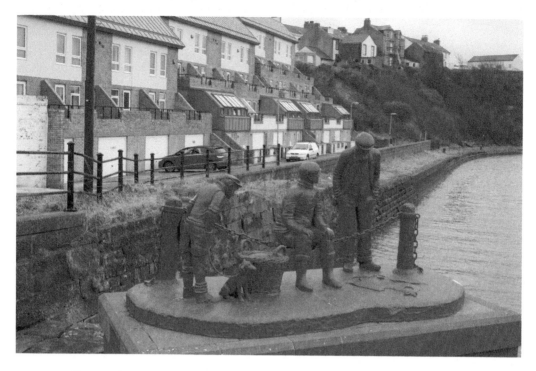

A group of bronze figures by the harbour bridge.

Looking down on Maryport's harbours from the Sea Brows.

was Ellenfoot, a small village gathered around the mouth of the River Ellen, roughly within the area of today's harbour.

Before the present town existed, the river mouth was naturally much wider, and it has been postulated that the Roman harbour that served the fort and its vicus once occupied the present harbour site, which lies across the mouth of the Ellen. The river mouth is on the south side of the fort, the vicus on the north. This meant that the fort stood between the harbour and the Roman town.

However, some opinions have changed quite recently. To the north of the vicus (Roman town), just beyond Maryport's golf course, there is what some informed opinions believe to be a silted-up natural harbour. This would mean that the vicus grew and developed naturally between fort and harbour – a much more convenient and practical solution.

It will be interesting to see which Roman harbour site is eventually proven, north or south.

The River Ellen

There are a number of major rivers feeding the Solway. The Ellen is almost a 'secret' river and little is written about it.

The River Ellen flows into the harbour to join the sea at the bottom of the shipping brow. At first sight, the mouth of the River Ellen can look somewhat modest when compared with the Derwent. This is probably partly due to the construction of the existing harbours that are mainly contemporary with the Senhouse development of Maryport.

Exactly 21 miles long and rising in Overwater in the heart of Lakeland, the Ellen is a spate river and accurately described as a wild river. I believe Ellen itself is a more 'intimate' river than the mighty Derwent. I am told that otters can be seen feeding in early morning or late-evening light. There are water voles and kingfishers (I have to say that I have not seen a kingfisher since I was a child, and am delighted to hear that they frequent this lovely waterway). The main fish in the Ellen are brown trout, sea trout and back end salmon.

There is evidence of a Roman fort at Overwater, and other evidence of continued occupation and use of this waterway is amply demonstrated by the number of mills that occupy the Ellen's banks. There were six in all: Blennerhaset, Irirby, Rosgill, Birkby, Bullgill and Outerside. A keen and expert fisherman, to whom I owe my information on the Ellen, also told me of a possible seventh mill race.

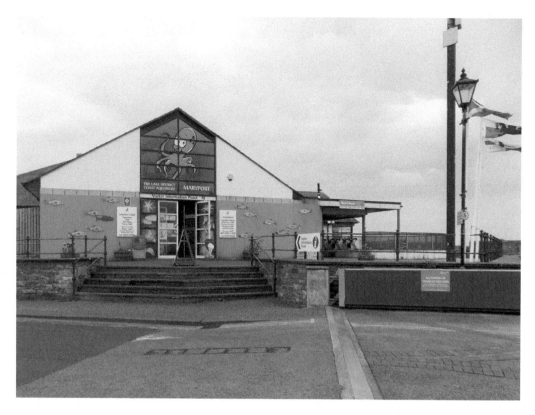

The Lake District Coast Aquarium.

The Lake District Coast Aquarium

Maryport's harbours were extensively rebuilt in the late 1980s and '90s. Part of this development included attracting new commercial life to the area.

One of the most successful ventures is the purpose-built aquarium. A low, attractive building with wide windows making the most of the views, the aquarium and its tea shop opened in May 1997.

The Lake District Coast Aquariums aim is 'to focus on and feature local marine life, as well as having some fresh water potential, and to do so in an informative, and educational way'. This combination appears to work, attracting visitors, locals and school groups.

The aquariums experienced owner Mark Vollers, a former director of Angelsey Sea Zoo in North Wales, hopes to continue the success and update on the present lines.

Long before Maryport, or Ellenfoot, or any of its derivative names, there was Alauna, a place of a size and importance that is only recently becoming more and more apparent.

The Senhouse Roman Museum

High on the Sea Brows, overlooking the wide stretches of beach sits The Roman Senhouse Museum. The unusual building that houses this museum was built as a Naval reserve training battery in 1885. It is an unusual and attractive building for such a use, and local apocryphal tales tell us that at the time of its construction, the current Mrs Senhouse, a woman of some fashion, declared that if she had to have a gun battery, at least let it be attractive.

The battery was never to see a shot fired in anger, if we are to believe local tales. The owners of the great houses on Camp Road, just above the museum, insisted that the guns be taken to the beach for the test firings to avoid any possible disturbance.

Over the years, the battery fell into disrepair. Taken over by the Senhouse Museum Trust in 1985, the building was renovated and reopened as a museum in 1990.

Now part of Hadrian's Wall World Heritage Site, a prize-winning museum and home to the largest collection of Roman altars found on a single site in Britain, the Senhouse Roman Museum stands beside Alauna, a 6½-acre Roman fort and a major site within the Roman coastal defence system.

This large fort was built around AD 121–122, which makes it Hadrianic. Alauna is built over an even larger fortification, thought to have been a palisade fort. It is said that the represent stages of conquest and consolidation. Current opinion is that Alauna and Arbeia in South Shields, on the east coast, sat at either end of a major supply chain. There is evidence of a large vicus on the north side of Alauna; this was suspected and then confirmed by a Geo-Magnetic Survey in 2000–02.

Unsurprisingly, the fort and its surroundings have been used as a source of stone for generations, and now the only pieces of stone showing above ground are in the north gateway. These stones are worn with long use and show tracks where cart wheels have bitten in. Interestingly, this pattern of wear shows the distance between roman cartwheels to be the same as the gage of our modern rail system.

Camdan, who I always think of as an Elizabethan Nicholas Crane, visited the fort when staying at Netherall in 1599. He was later to comment in his writings that the fort walls were then 13–14 feet high. Originally, they would have been nearer 20 feet.

A great deal of Maryport and its surroundings is built of fort stone; it's simple and practical recycling. We must also never forget what great 'collectors' our ancestors were, especially the Victorians.

Since their discovery, the large number of alters found at Maryport (or should I say Alauna) has been a matter of debate and speculation. Most

Looking upcoast towards Allonby Bay, taken from the Senhouse Roman Museum Tower.

were discovered close to the modern trig point above the vicus, which sits to the north side of the fort. The local story is that in the late 1800s, a plough had caught a lump of stone that subsequently turned out to be a Roman alter. Mr Senhouse, who was an avid collector of antiquities, instructed some of his men to explore further. It is all very neat and I dare say holds a lot of truth. The possibility also exists of alters being found, and possibly sought, over a much longer period of time.

Excavations

Over the last three years, a number of highly successful digs have been taking place under the auspices of the Roman Senhouse Museum and Hadrians Wall Trust. These excavations have been led by Newcastle University.

In 2011, the area of the alter pits was explored, and a highly complicated site was revealed, indicating that a series of previously unsuspected large buildings had occupied the area. There were very few finds, a fact that possibly indicated a ritual site. A number of pits were revealed, complete with Victorian 'back fill'. It was postulated

46

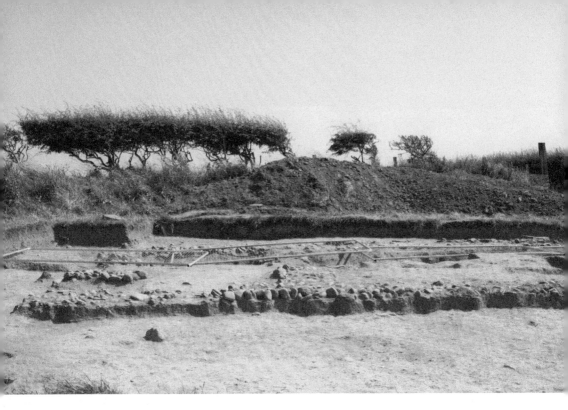

The temple excavation site. (*Photographs courtesy the Roman Senhouse Museum*)

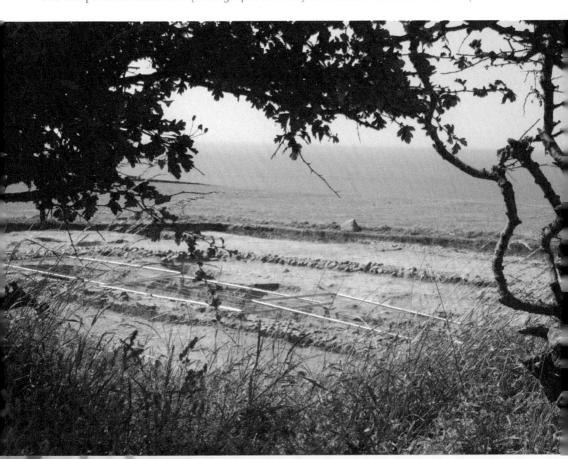

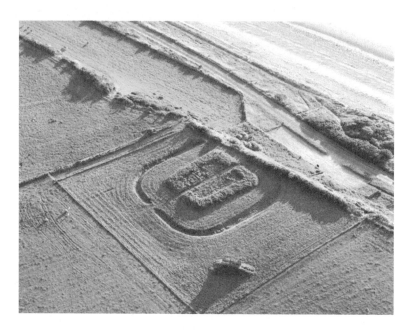

Milefort 21. (*Courtesy of the Roman Senhouse Museum*)

that, that far from being ritually buried, Maryport's alters had been used to line the postholes and help support large buildings.

In 2012, the 'alter pit' site was extended into a slightly different area and evidence of a large, timber building, possibly Romano British, was discovered. It was a season of highlights: an intact alter was found, undisturbed and in situ, thus proving beyond doubt that they had indeed been recycled as building supports.

In 2013, between the alter site and the vicus, Robinson had found and recorded several buildings that he described as temples. Part of Robinson's 'temple' site was reopened, and excavations revealed a classic temple, the farthest north that any such structure has thus far been discovered in Britain.

2014 looks exciting.

The views from the excavation sites are breathtaking, but it is private land, only open to the public by way of guided tours in the digging season. However, there is a replica Roman watch tower beside the Senhouse Museum that affords wonderful views of the firth and both coasts.

The Scottish coastline opposite Maryport is dominated by the mighty bulk of Criffel. At 569 meters, it is one of the higher tops in the Stewartry area, and it is worth looking for the cliffs of Rockcliff that are often seen from this point. But the Firth has a reputation for being hazy, which it lives up to all too often.

The sandy coastline cliffs and 'heads' begin to lose height around Workington, whether by industry, nature, or a combination of both, it is

difficult tell. They undulate upcoast, rising to the sea brows of Maryport, beyond which the coastline changes character to rolling dunes and curving bays. As the sea brows lose height, they curve inland slightly, and one very obvious feature is a distinctive bluff, known locally as Swarthy Hill, on top of which sits the excavated Milefort 21.

The B5300 branches off the A596 beyond Maryport, this 'B' road follows the coast as far as Silloth and will take you directly past the Milefort.

Saltpans

Milefort 21 is accessible from a marked path near the improved cycleway. From its vantage point, if the light and tide are right, the outline of the saltpans are visible in the bay below. Used by the Romans, they were rebuilt, maintained and used well into medieval times.

That the Saltpans have remained visible is one of many fascinating anomalies that you come across on this coastline of ever-moving tides and sands. The golf course between Maryport and Saltpans is divided by the B5300. Three out the nine holes that were on the sea side of this road have been lost since the 1940s; these have since been replaced on the 'land' side, leaving six holes to the left, and twelve to the right, as you go upcoast.

Other parts of the entire coast have been lost and gained somewhat erratically over the years, including chunks of road.

Beyond Saltpans is the wide curve of Allonby bay. 'Allan's Bay' was probably named after a past Lord of Allerdale.

Allonby

Hutchinson describes Allonby as a 'small, neat, pleasant market town'. In common with similar communities on this part of the coastline, it survived on a combination of fishing and agriculture. Early in the twentieth century, obsolete wooden ships were brought here for breaking, which added to the local revenue.

Contemporary Allonby is a charming village with an interesting mixture of houses. Many are Georgian, but there are older buildings, as in so many other such communities, on even older foundations. It is well worth taking time to explore away from the seafront.

A famous, although almost forgotten, son of Allonby is one Capt. Joseph Huddart, F. R. S. Born in the village in the 1730s, the son of a shoemaker, Joseph was a quick clever child. He grew to be a master mariner and a gifted cartographer. Eventually, his skills were recognised and he was elected one of the Elder Brethren of Trinity House and also made a fellow of the Royal Society.

Red Bridge, Allonby: a favourite subject of renowned local history artist, the late Percy Kelly.

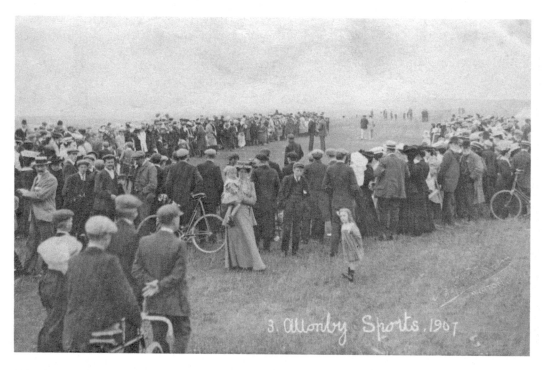

Allonby sports day, c. 1907.

Among his other achievements, he was particularly involved with lighthouses and lightships, when such aids to safety and navigation were in their infancy. There is a memorial to the Captain in Allonby church.

I am indebted to a comprehensive paper by Eric Hill, published by the Friends of Whitehaven Museum in 1984, for my information on Captain Huddart.

In the 1800s, the village became a place of some fashion. Among other amenities, it boasted state-of-the-art sea water baths, a fine building with decorative columns, complete with a ballroom/assembly room above. Although it has fluctuated over time, Allonby is still popular as a holiday or weekend destination. This is attested by the fields of chalets and caravan parks on the outskirts of the original village, and I am assured that it is an excellent bay for windsurfing.

Wilkie Collins and Charles Dickens came here during their tour of 1857, staying at the Ship Inn. While Dickens admired the magnificent sunsets, Wilkie Collins was said to be less impressed, possibly the fact that he was laid low with a sprained ankle didn't help.

There is one of those wonderful, probably impossible to prove local stories connected with Collins, visit here. It says that the writer found inspiration for his 'Woman in White' in a local ghost tale. There certainly are several 'woman in white' in the vicinity. Frustratingly, I do not have the space to mention them all but two particularly stand out as possible candidates.

One, possibly the most famous, is the Beckfoot Boggle, although the other, the Red Bank Boggle, is usually the local choice.

The Red Bank Boggle

We have to go back down coast to Croft – or more accurately White Croft Pit – for this tale. The pit was on Red Bank, which lies between Flimby and Ewanrigg, Maryport. It is interesting to note that Ewanrigg Hall and its estate are said to be haunted by a White Lady, and this estate also features in one of Cumbria's many 'Golden Coffin' stories. Ewanrigg's coffin is said to hold either a chieftain or a Roman woman in a white dress.

The Red Bank story itself is a fascinating fusion of ghosts and folklore. There are a number of versions of the White Croft haunting that all seem to agree on the main detail, which leads to the conclusion that there is possibly some truth behind the tale.

Sometime in the nineteenth century, accounts began to spread of an apparition, a headless woman in a white silk gown, visiting the engine

house of White Croft Pit. According to some accounts, the rustle of her dress was almost as terrifying as her appearance. At first this entity was seen only by the engine men, but gradually others began to see her and were uniformly terrified.

Apparently, when first seen, the apparition only appeared at the doorway of the engine house, but eventually she turned her attention to the building and began to enter, on one occasion pointing towards the engine then disappearing. At the end of the subsequent shift, as the cage was being raised, the winding cable went out of control and several men were killed. At least one version says the winding man lost his head, and over time there were several other accidents and deaths.

We are told that White Croft's headless, silk-clad lady finally had the distinction of closing the pit down, for in spite of the offer of higher wages no one would work in the engine house.

Why this particular tale is the locally preferred one for Collins' inspiration is difficult to say.

The Beckfoot Boggle

Beckfoot, Roman name *Bibra*, lies between Allonby and Silloth. There is a Roman fort and cemetery at Beckfoot, and over the years this location has been the source of some fascinating finds and studies.

The story associated with Beckfoot could be called 'generic', as it is a story of forbidden love. I find it fascinating how persistent such stories are and how easy to believe; they say so much about human nature. As always, there are several variants of the basic outline, but these are small enough to be negligible and, given the story's age, the similarities that still exist between versions could be called remarkable.

The variation is simple: sometimes the lovers are said to be a Roman of rank (the more romantic say a General) and a British princess, or, a Roman woman of rank and a British chief. Forbidden love across a divide.

The most common version is that of a Roman man and British woman, and it is basically very simple: it tells of the man being killed by the woman's tribe, and the distraught girl drowning herself in the Solway. It is this girl, dressed in white, who is said to be seen at Beck Foot. She is observed either walking the tideline or gazing out to sea.

There is a relatively unusual aspect to this Boggle tale, in that she is not seeking vengeance for her own death, but for her lover's murder. It is worth mentioning that Bank End is sometimes associated with this story, but by far the most accepted location is Beckfoot.

I often think that some myths are an amalgam of folk tales, real experience and a kind of genetic memory; also, I believe that many

reflect their location. Taking the Solway coast as a whole, there are a number of very old traditional stories telling of disappearances and warning of caution. This says a great deal about an area of fast, dangerous tides and moving quick sands.

Some of the oldest warnings are the tales of 'Sea Wives', and they are specific to an area stretching from Maryport to Bowness, or thereabouts.

Sea Wives

Sea Wives are immortal creatures that rise from the sea when certain conditions prevail. 'There on the Solway when the sun lies low, and you can scarce tell the difference between land and sea, there-on that line of silver; Sea Wives rise.' Interestingly, the conditions described are relatively common on the Firth.

The creatures take the form of beautiful women, and they are said to enchant young men and lure them to their realm beneath the sea. Only rarely are they said to take children. Those who are taken are said to return on occasion and, in spite of passing years, appearing as they were at the time of their disappearance. It has been mooted that the myth could be rooted in people either disappearing into the sands, or being kidnapped into slavery.

There is another, slightly different, intertwined version of these stories. It tells us that these fabulous creatures have magical cloaks of sealskin, which they cast aside when ashore. Any man who braves the sands and manages to steal one of these garments has the Sea Wife 'in thrall', and she is bound to become his bride. Such marriages can bring great wealth and power, but if ill treated the creatures can wreak havoc, causing great storms and damaging crops. This seems perhaps to be more aligned with kidnapped brides – not an uncommon event through certain periods of northern history.

This second version also has much in common with the Seal Wives and Silkies of Scotland's north-west coast, and parts of Cornwall.

In common to every version of these myths are warnings to beware the tide lines and sands. Quick sands are difficult to spot at any time, but it was pointed out to me quite recently that, in the conditions describing when Sea Wives are said to rise, it would be virtually impossible.

How would you recognise a Sea Wife? They don't leave footprints in wet sand: beware!

Sea Wives are fabulous creatures, but Boggles are quite a different kind of entity. In the North West, it is believed that a Boggle is the shade of a person who has died tragically and unavenged.

Blitter Lees, a fascinating name, lies between Beck Foot and Silloth.

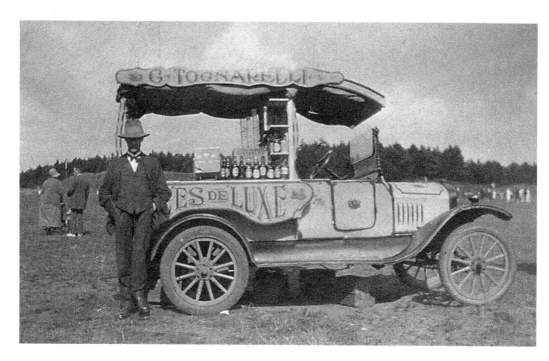

Settling in Workingston around 1880, the Tognarelli family set up one of the first ice cream factories in Cumbria. They also owned and ran some of the first coffee bars/ice cream parlours. There is still a Toggies in Workington. These rare photographs, from the 1920s/'30s, were taken on the green at Silloth, or possibly Blitterlees.

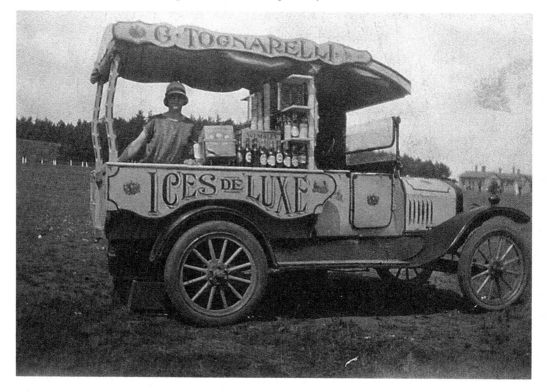

Sedgefield simply lists it as 'Bletterley' and 'Bletterless', offering no meaning. In fact, there are place names all around the Firth that intrigue without having real explanation. Some, however, are obvious. Tarns, a hamlet inland of Beckfoot, boasted a tea room and boathouse alongside its tarn in the 1920s. Some 200 years previously, Tarns was involved with the Solway smuggling trade in the shape of Scots and Irish Whiskey, plus other cargoes from the Isle of Man.

Silloth

Silloth sits on what was abbey land. The name is said to derive from the Norse for barn. Much of the land hereabouts belonged to Holmcultram, and there is also a school of thought that places grain storage for the abbey in this area. Such continued common usage – Norse to Norman – would not be unusual.

The B500 ends at Silloth. The town boasts wide, cobbled streets in wonderful condition, and a church built of Irish granite overlooking the broad green that lies between the long-stepped promenade and the town. This promenade is the latest in a line of defences built in an attempt to prevent coastal erosion.

Discovered to be a 'healthy' holiday venue by the Victorians, the town has a reputation for 'good air'. There are photographs showing wheeled bathing huts on Silloth beaches in the 1860s, demonstrating a 'proper regard for public modesty', which, according to contemporary newspaper reports, was made much of.

Due to its popularity, the town continued as a resort from the 1920s until the 1960s, from which point, as in many places, holidays abroad began to make their mark. However, modern Silloth still has its visitors, as the adjacent caravan and trailer parks attest.

On the outskirts of the town, the airfield and hangars speak of its importance in the Second World War. One of three large airfields (Silloth, Kirkbride and Anthorn), Silloth was a maintenance centre and was responsible for the training of bombing crews. Sadly, so many planes ditched in this part of the Solway that it earned the nickname Hudson Bay.

The port of Silloth, developed as a Railhead in the 1850s, was regarded as a 'safe port' during the Second World War. It has continued as a commercial operation, and has handled many varied cargos over the years. One of the port's oldest customers has got to be Carr's mill, which first opened here in 1886. Many people have reminisced to me of a particular boat called the *Yarrow*, which regularly brought cattle from Ireland. I am told that its arrival and unloading usually attracted a crowd of interested spectators.

Looking back towards Silloth from the Skinburness Road.

Criffel from Skinburness

Beyond Silloth, the B5300 becomes the B5302, which takes you towards Abbey Town and Holme Cultram. It is well worth taking the side road to Skinburness – again, you will miss a great deal without a good map. This is an area for exploring, and one where the layers of history feel as though they are just beneath the surface. The wildness, muted colours and lighting are all fantastic and evocative. One of the most wonderful things about the Solway is how it appears to change its nature in a few short miles.

Remnants of what is said to be the Green Knight's Castle, or chapel, as in Sir Gawain and the Green Knight, lie at Grune Point, a spit of land that juts out into Moricambe Bay. Someone thought fit to cover the few stones left with concrete and turn them into a gun emplacement, but for those interested in the legends of King Arthur, the site is worth visiting for the location and the walk.

The walk begins (and should be signposted) beyond and behind the Skinburness Hotel. There are other approaches, but it can be very wet and it is advisable to stay on the footpath. The road turns sharply in front of the hotel. This fine period building has suffered with the years and is now boarded up. When it's misty and quiet, as it can be, it is all too easy to think of past holidaymakers and the young men and women who must have met and danced here during the war years.

Skinburness, looking towards Chapel Cross.

Skinburness

The area around Skinburness can look eerie, possibly because of the soft, grey light you get there so often. The name is believed to be partly personal, and a number of opinions associate it with the site of a personal grave mound.

The present Skinburness is a scattering of houses and farms of varying ages and history; there is little to show that the village was once a thriving port and market town. Its market charter was granted by Edward I (Hammer of the Scots) who used the town and harbour as a garrison to service his troops for border raids during the Scots invasion of 1299.

Skinburness did not hold its charter for long. Granted in 1304, it was soon to pass to Newton Arlosh after a violent storm broke through the sea dyke and swept Skinburness into the Solway. The dates given for this event are 1304/05. Local lore tells us that this catastrophe happened within a single night. Anyone who has witness, Solway storms and is familiar with the locality will find this totally believable.

In more recent times, there was a ferry route between Skinburness and a point somewhere between Annan and Gretna. There were occasions when weather, tides and sands dictated the exact landing place. It was a route sometimes used by fleeing lovers at a time when the Scots' marriage laws were more liberal than the English in terms of consent. There are a number of stories of screams being heard said to be the voices of those who, in desperation, risked the crossing in foul and dangerous weather.

The village has its place in literature as well as history, Sir Walter Scott set some scenes from *Redgauntlet* here. Some speculate that remnants of 'the long house' featured in this novel still lie under some later buildings.

From Skinburness onwards the Firth begins to look like the Old Norse *Sol-vagr*, 'muddy bay', or 'Sulewad', a ford or crossing. But it would be more than unwise to attempt a crossing; these are dangerous sands and tides, as the public notices and lifebelts attest. I believe that there are experts who know the sands and fords, best to leave such things to them.

Not surprisingly there are folk tales of incidents demonstrating the dangers of the tide and sands. One of the oldest tells of two brothers, and a misshapen ghost that appears to have two heads.

The Two Brothers

Long ago, there were two brothers who lived close to the Solway. The area is often given as around Moricambe Bay. The brothers had long been vicious rivals, but the reasons why are not clear. However, things came to a head and one brother killed his sibling. The more common version of the story tells of them agreeing to fight to the death.

Fearing some retribution, the survivor hid his brother's body, planning to dispose of it in the quick sands. He knew the tides and sands well, so when he judged the time right, hauling the corpse onto his back, he set off in the half-light.

The victorious brother judged the tide and sands correctly, but there was one other vital timing that he forgot. On reaching his planned location, he found that *rigor mortis* had set in and he could not release his dead brother from his back. As he struggled to free himself of his burden, the rising tides and softening sand took both murdered and murderer down.

The brothers are sometimes seen in the half-light, so entwined that they appear as a misshapen entity with two heads.

There is another tale of fast-moving tides and sinking sands that is associated with this upper stretch of the Firth, and this, too, is more often associated with Moricambe Bay than any other location.

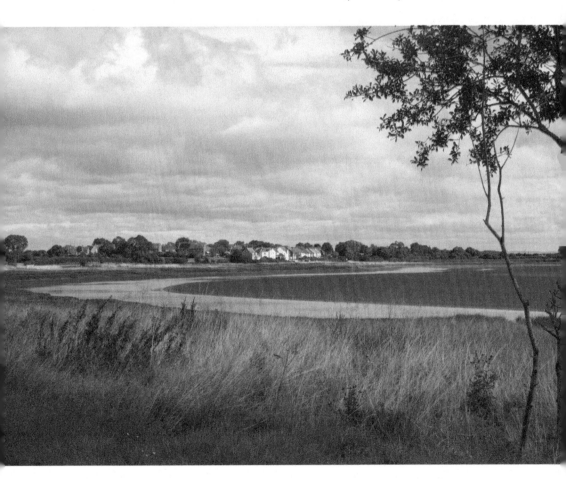

Moricambe Bay, looking towards Anthorn Village.

Ghost Horses

Ghost horses are among the most persistent and oldest folklores of the Solway sands. There are apocryphal stories of riders testing their horses by riding them on the edge of the incoming tide. These stories tell of races and wagers. Racing on the sands could well have been a popular, if dangerous, form of sport. The most hazardous form of this sport was galloping just ahead of an incoming tide, known as 'racing the tides'.

I am assured on good authority that it would be impossible for even the fastest and strongest of animals to beat the tide, for the sand would soften ahead of the tide line, eventually bringing down both horse and rider, who would be fortunate to escape with their lives. It is said to be the victims of such events who haunt the tidelines.

There are, of course, variants to these legends. One common version tells of magical horses that live beneath the Solway waves and are seen on the tide line at certain times. Sometimes phases of the moon are quoted. These magnificent creatures allow themselves to be caught and ridden, but anyone who is foolish enough to do so is never seen again.

This leads very neatly to yet another warning. In the past, children were told to stay away from the beach, at dusk or dark, otherwise the Ghost Horses would take them. This was common as far downcoast as Blackpool. No one appears to be entirely certain how old the Ghost Horse legends are, but that they lasted into modern times is certain. I have met people who, as children, were warned away from the beach after dark because 'the Ghost Horses would take them'. As a parent, I think that it probably worked far more effectively than 'stay away from the beach after dark, it's dangerous'.

Similar warnings associated with Cornwall are thought to stem from attempts to frighten people away from smugglers tracks and dangerous beaches. This makes me wonder if some of the Firth's stories were also used to keep the curious away from smuggling haunts. Sir Walter Scott, frequently used both Ghost Horses and smugglers in his novels.

Moricambe Bay is wedge shaped with two major inlets: the rivers Waver and Wampool. It is said that, in places, across the mouth of the bay there are spiked posts buried in the mud that were placed there as a Roman defence against the Scots. There is also evidence of much more recent conflict around the bay, the airfield at Anthorn was operational during the last war and ruined brick structures from that dark time are still to be seen around the area.

Anthorn is also the home to state-of-the-art technology in the shape of the Anthorn antenna, which is responsible for the MSF Radio Time signal. Alongside technology there is nature preservation. A few miles beyond the antenna lies Campfield Marsh, an RSPB nature reserve.

Campfield Marsh.

Campfield Marsh

On my visit to the centre, I was fortunate in being met and escorted by Norman Hotter, senior sites manager for Cumbria Coasts Reserves. Any knowledge that I appear to show when writing about Campfield Marsh is entirely due to Norman's expertise and experience.

There has been a wetlands site here for twenty-five years. The new centre, with its education suite housed in a beautifully renovated building, was opened in October 2013. Present projected planning includes extending the site's access routes and a circular walk. It is hoped that all this will be achieved within the next year.

The nature reserve includes the estuary, where worms, cockles and shrimp attract thousands of birds, including grey plovers and oyster catchers. Farmland, where natural hedgerows attract a wide variety of birds, such as buntings and finches, while wetter areas are ideal for wading birds. Lowland raised peat bog, a particularly rare wildlife habitat.

One of the aims is to attract and involve children in workshops centring on birds, flowers and butterflies, thus both waking and engaging the children's interest. The local school at Bowness on Solway is being involved in a project to develop a natural play area, which will feature pond dipping and insect homes. It is also hoped to mirror what is achieved here in the centre within the wider countryside.

Beyond Campfield Marsh lies the intriguing village of Bowness on Solway. There are a number of places called 'Bowness', especially within the Lake District: Bowness on Widermere, Bowness Knot Ennerdale, Bowness point on Bass lake and one or two others. Bowness is thought to mean headland or promontory.

Opposite left: Iron and stone that looks like a work of art.

Opposite right and below: Timely warnings in this area of soft sands and fast-moving water.

WARNING
BATHING IS DANGEROUS
OWING TO FAST RUNNING
TIDES, CURRENTS AND
TREACHEROUS SANDS.
IT IS UNSAFE TO VENTURE
OUT AT LOW TIDE
BOROUGH OF ALLERDALE

WHEN WATER REACHES
THIS POINT MAXIMUM
DEPTH IS 2 FEET

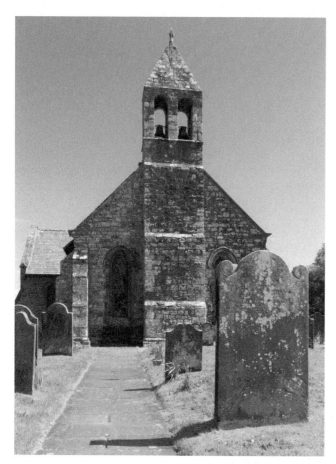

Left and below: Bowness church. This simple and beautiful church of St Michael in Bowness on Solway is said to be built of stone from the Roman camp and wall. The present building is much altered from what was probably a Norman original.

Opposite: Smugglers Grave: Beside St Michaels, unknown smugglers lie buried beneath and ancient Yew tree. Only one is named: Thomas Stoal of the Isle of Man. According to the church leaflet, his wife carried his headstone, which was made of Snaefell Slate, from Maryport.

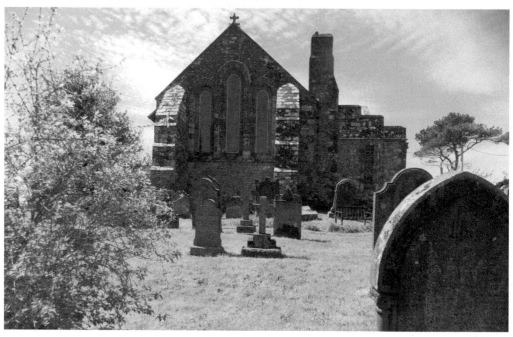

Bowness on Solway

The village of Bowness on Solway is situated on the Roman wall path and lies across the site of a Roman fort called *Maia*. There is a signpost in the village pointing to what is left of this fort; there is now little to see other than bumps in the grass, but I admit to being fascinated by both these and also what must be under the houses and gardens.

The thought of what may lie beneath is one of the reasons why I find this village so intriguing. Its atmosphere fascinates me, and sometimes there is a quiet stillness that makes it all too easy to imagine smugglers and excise men in some of its narrower twists and turns. I am aware, however, of how much and how easily we can – and sometimes do – romanticise smuggling and aligned activities. In reality, I suppose it probably ranged from an almost day-to-day, dangerous slog of making a living, to the bloody and brutal. Being only a mile or so from the border, Bowness has seen its share of both raiding and smuggling. There is a yew tree in the churchyard, where, according to local legend, unmarked graves of drowned smugglers are said to lie.

The Solway Rail Viaduct crossed in this area. It took the shortest route between Bowness and Annan. Constructed in 1869, the engineer responsible was Sir James Brunlees. This viaduct was (it is recorded) 940 yards long, and we are told that its main purpose was to carry freight, chiefly iron ore for the Lanarkshire steel industry, but it was also popular with passengers. How spectacular is must have been to rice above the racing tides.

Damage by ice flows caused its closure in 1875. (Ice flows in the Solway are worth a comment.) However, this feat of engineering was subsequently repaired and continued in use up to 1921, before finally being demolished in 1934/35.

For those who know it intimately, the higher Solway is fordable, but never to be attempted without a knowledgeable guide, and these fords were regularly used in the past. Tradition tells us of a hazardous Wath (ford), one side of which emanates from near Bowness, that was used for transporting cattle to and from Scotland; the other side is probably close to Annan. There are a number of what could possibly be described as 'traditional' Waths across the head of the Solway, and it is not always easy to fit the historical descriptions into our modern landscape.

Stories of flight of incidents and narrow escapes aboundacross this dangerous land, both in fiction and in fact. One infamous incident was the drowning of around 2,000 Scots in 1216. Apparently, returning from a raid into Cumberland, they raided Holme Cultram abbey against orders. This somewhat vicious detour led to a miscalculation and they drowned in the rising tide.

For many raiding parties, in either direction, it must have often been a straight choice between crossing the Solway or crossing the River Eden, both dangerous options.

The River Eden enters the Solway a few miles above Port Carlisle, which sits at the mouth of the Carlisle Canal. Remnants of the abandoned port and canal are still to be seen, but the seas have taken, and continue to take, their toll. The sandstone blocks that remain, especially at the canal mouth, show evidence of fine workmanship.

Carlisle Canal

Opened in 1823 and drained in 1853, the Carlisle Canal was 11 miles long and dropped 60 feet by way of eight locks. The first ship to negotiate the new waterway was the *Robert Burns*. Unfortunately, the venture was never a financial success. A railway line was laid in the dry canal bed, and it closed in 1932.

There are a number of apocryphal stories telling of the artefacts that were found during the digging of the canal. How much truth there is in these accounts, it is difficult to say, but anyone looking at the general area of construction and knowing something of its history would probably be much more surprised if nothing had been found.

The more persistent of these accounts tell of gold jewellery, including several torques. What happened to them? It is said that they were sold to local jewellers at scrap weight and melted down. This is believable, for in the not too distant past artefacts were not always valued for what they were, at least by the general public. Also, if you were digging mud in every kind of weather for sixpence a day and you came across a chunk of gold, the temptation would be to sell it.

Although not directly on the Solway itself, the great border city of Carlisle sits as it does, a sentinel to the western Borders. The banks of the Eden have been intimately connected with the Firth's folklore and history.

The ruined quays of Port Carlisle.

Fine stonework at the mouth of the disused Carlisle Canal.

Port Carlisle
to Wigtown

Carlisle, Reivers, Smuggling, Gretna, Annan, Dumfries, Sweetheart Abbey, Caerlaverock Castle, Caerlaverock Welands Centre, Mermaids, Southerness, Rockcliff, Palnackie, Dalbeattie, Kippford, Auchencairn, Balcary, Dundrennan, Kirdcudbright, Wigtown

Carlisle

Carlisle is a true border city. Its superb defensive site has been occupied since pre-Roman times. Fortified by the Romans, it was destroyed in the aftermath of their departure. Somewhere between this post-Roman period when it was being rebuilt by the King of Northumbria in the seventh century, Carlisle became associated with King Arthur. It has to be said that there is a great deal of evidence for what is now Cumbria being an Arthurian location. The city was pillaged by the Danes in the ninth century, and then left in a semi-ruined state until *c.* 1092, when William Rufus garrisoned the castle.

Mary, Queen of Scots, was imprisoned in Carlisle Castle in the aftermath of her abortive attempt to seek Elizabeth's help. Mary's incarceration was called protective custody. With hindsight, we can now see it for what it really was. Almost 200 years later, the city submitted to the Scots in the 1745 rising and saw Charles Edward (Bonnie Prince Charlie) proclaimed King.

To say that the city has, for centuries, held influence and felt the swings of border politics and changing loyalties is an understatement of some proportion.

Carlisle is synonymous with the River Eden, a water course interwoven with border history and legend that is also so much a part of the Solway's past. But Brian Blake reminds us in his book, *The Solway Firth*, that crossing the nearby River Esk can be just as dangerous and problematic as attempting the Eden. He sets out an articulate and persuasive argument for the possibility of the original 'Sulwath' being the name of a ford on the Esk that has, over time, been adapted to the Firth itself.

In centuries past, to round the head of the Solway from the south meant either fords, Carlisle and its hinterlands or a long detour. Now,

of course, we rely on our road systems; the most efficient is currently the M6 to the A75, or the A595 to the A75, and of course the new bypass now makes it possible to avoid the congested roads that pass through Carlisle at the foot of the castle mound.

Carlisle will always be synonymous with the great border lands and the borders with Reivers. This is a period of history that, like so many others, has been fictionalised, romanticised and, in common with 'Bonnie Prince Charlie', has become rich subject matter for countless novels, plays and films. Sometimes I think that we partly fictionalise the past to make it easier to accept.

The truth however is bloody and brutal, and there are some fine factual writers who cut through the myths to show us real people, many of whom must have been struggling just to survive in a period of history that must have felt like hell.

Reivers

Edward I is held responsible for more than 300 years of slaughter and lawlessness that were to go down in history as the time of the Reiver. The trigger was a vicious invasion of Scotland and a massacre in Berwick in *c.* 1286. This began what was to become a savage spiral of revenge, which quickly turned into general lawlessness as family fought family and neighbour, neighbour. Most people will be aware that the terms 'bereave' and 'blackmail' were spawned in this period.

The Reivers' area of influence stretched from, and included, the Solway Firth, and spread as far as the Berkshire coast in the west. One government attempt to regain control was to divide the disputed lands into 'marches', three on either side of the border. But the wardens appointed to govern them proved to be as dissolute, and sometimes as vicious, as the factions that they were meant to hold in check.

In time, a manmade ditch, called the 'Scots' Dyke' was constructed to divide the area disputed by some of the most notorious border families. Elliots and Armstrongs to the east; Grahams and Bells to the west. But it would be the end of Elizabeth's reign before the borders were to find an uneasy kind of peace.

King Edward was to die on the border marshes in July 1307, his body being laid in state at the wonderful old church of St Michael, Burgh by Sands.

Opposite: King Edward I's (Longshanks') statue at Burgh by Sands. Edward laid in state at St Michaels church, Burgh by Sands – the visiting dignitaries must have taken the small community by storm.

Burgh by Sands

'Burgh' is a common element and simply means 'fortified place' or 'walled town'. Like so many other villages and towns, Burgh (Bruff) by Sands stands close to the site of a Roman fort. The Roman name for this site, *Aballava*, is sometimes said to be associated with orchards and/or fruit trees.

Made a barony in 1092, Burgh by Sands' thirteenth-century castle no longer exists. We are told that it was demolished. I am certain that its stone, possibly mainly Roman cut, would be put to good use. The church, and I suspect quite a number of the seventeenth- and eighteenth-century houses of which the village now chiefly consists, have their share of fort and wall stone in the construction.

As well as instigating policies that gave rise to the Reiver, Edward I has been credited as being responsible for the origins of smuggling on the Solway and Borders.

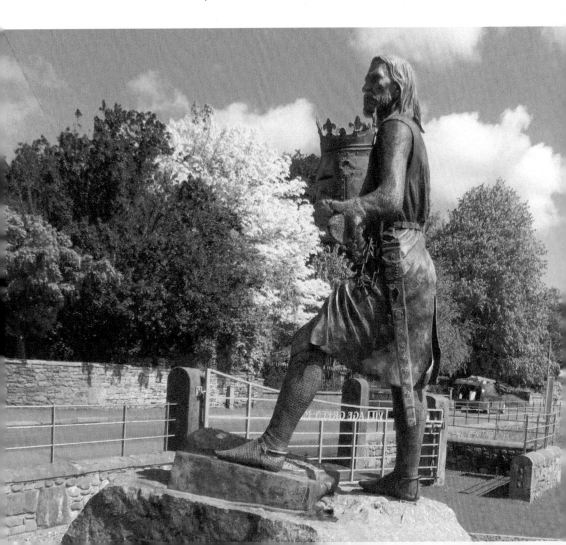

Smuggling

It is possible to follow in the footsteps of some of the Solway smugglers by way of a walker's route – 'The Smugglers Route' – from Maryport to Ireby. A comprehensive guide book for walks, *The Smuggler's Route*, produced by Solway Rural Initiative Ltd, tells us that Edward, needing money for his conquest of Wales, imposed heavy taxes on wool leaving the country. At that time, *c.* 1275, wool was Britain's largest export and the King's 40 per cent tax hit hard.

Many merchants, who wished to continue their overseas trade unencumbered by the extra tax burden, smuggled wool out. 'Smuggling as we know it developed from carrying wool overseas and bringing goods-liquors, fine textiles back.' It is possible that some of the abbeys, which were major producers of wool, did not object to this trade.

In the eleventh century, the biggest religious establishment on the English side of the Firth was the abbey of Holme Cultram in Abbey Town. A Cistercian house, the brothers here kept flocks of over 6,000 sheep

When looking into the history of smuggling, it is easy to imagine that most of the Solway shore and quite a lot of the hinterland have been, at one time or another, involved in the smuggling trade. Indeed, Solway folklore is rich with incidents.

There are many stories associated with smuggling: secret rooms, hoards and ghosts. It is commonly accepted that some ghost stories were invented to keep the curious away from landing places and paths. A fascinating fact I came across in the guide told of 'tub men', those responsible for actually unloading the contraband, who were dressed in white smocks. From a distance, they would have looked like ghosts.

From time to time you hear legends of hoards and caches being found. The contraband habitually smuggled probably would not stand the passage of time, but to find an actual hiding place has got to be fascinating from a social history aspect.

I have been told, first hand by the man who discovered it, of a locally famous (or perhaps infamous) secret room. Some seafront houses were being demolished on the Cumbrian coast and, as so often the case, there had been building and rebuilding over old foundations. My informant, who had lived in the area as a child and was involved in the demolition, was determined to test the local story.

The room's entrance was low, in a corner, and cobbles had been cemented across a well constructed entrance, but it was fairly obvious that there had once been panelling there. There were sturdily-cut stone steps and a beaten earth floor, as well as a strongly constructed, completely enclosed, workman-like room that was absolutely, disappointingly, empty. But the story had proven true!

To consider the map of the Port Carlisle area, the number of villages, hamlets and twisting roads show what an ideal smuggling location this must have been. Looking around at the age and variety of buildings, you begin to think of hiding places. Also, the channel here, where the Eden and Esk divided by Rockcliff Marsh enter the Solway, is relatively narrow.

Smuggling was endemic around the Firth but, as with everything, I presume that some locations were more naturally suited than others.

Driving around the Solway Firth, on our metalled roads and steel and concrete bridges, I often think how we are now able to cross areas of what was difficult, and at times dangerous, land, while barely being aware of its existence.

For instance, when in Gretna/Gretna Green, 'the first village in Scotland', it is hard to envisage how close to the Solway coastline you actually are, or how easily the rivers, which were once a great barrier in this traditionally romantic border journey, are now crossed. I freely admit to barley noticing the river crossings as I drive north.

Gretna

Gretna means 'gravelly hill', making Gretna Green 'the green by the gravelly hill'. This title appears to have no immediately obvious connection with what we can see of the modern Gretna.

Before 1754, 'irregular marriages' could be performed anywhere in Britain. It was a change in this law that prompted the tide of runaways seeking the border and a quick, simple ceremony, hopefully before the pursuing relatives caught up. It was eighteenth-century Scots law that allowed marriage by means of 'declaration before witnesses' that was the attraction to young, absconding couples.

I am sure that we are all familiar with the dramatic images (usually in atrocious weather) of galloping horses and pursuing fathers. In the past, this journey north could prove both difficult and dangerous. There are stories, some no doubt based on truth, of desperate couples taking tremendous risks when either crossing the rivers or attempting the Solway. As mentioned previously there is at least one Solway ghost story that concerns a drowning lover's voices being heard on the wind where they came to grief during an abortive crossing attempt.

Such were the numbers of couples seeking to bypass the marriage laws in England that, by the law of average, some of the tales of tragedy are almost bound to be at least part true and based on actual incidents. The couples must, on occasion and depending on their desperation, have been risking fords in conditions that had brought armies to grief.

The marriages took place in a variety of locations: the Sark Toll Bar, probably more familiar as the 'first' house in Scotland on the old A74; local Inns; the famous 'Old Smithy' at Gretna Green; and Gretna Hall, which was built in 1710. Between 1825 and 1855, 1,134 marriages were recorded as being performed in Gretna.

An act was passed in 1856 necessitating residence of three weeks in Scotland before a marriage could take place, which would appeared to have stemmed the flow of lovers a little.

Gretna Green is a popular modern choice for a marriage venue. Picturesque weddings are often to be seen in the village, complete with piper and horse-drawn carriage. Nowadays, there is usually a full complement of relatives who are supporting and rejoicing, rather than pursuing.

I was reminded by an old gazetteer that the bridge over the River Sark is (or was) the actual border. I do not know if the bridge referred to in this instance is past or present; it is a very old book and so much has changed. The same publication goes on to tell us that the River Sark flows into the Solway, 'a place of dangerous tides which occasionally form a bore nearly four feet in height'.

The A75 or B721 will take you to the town of Annan, the other side of the Bowness crossing. It is relatively simple to follow the coast on this side if the Solway. Beyond Annan, the B724/725 will take you close to the coast as far as Dumfries, then the A710/711 from Dumfries to Kirkcudbright.

Annan

Thomas Carlisle was educated at the old grammar school in Annan. An attractive town, it sits beside the River Annan, another of the Solway's tributaries. The river is tidal and, to quote an old guide, 'noted for its fish'. I love the turn of phrase in some of the old tourist literature. Annan Waterfoot on the Nith Estuary was the landing and embarkation point of the Bowness ferry crossings. Remnants of the rail viaduct that superseded it are still to be seen.

In the past, ships simply beached at Waterfoot to be floated off at the next tide. A plaque to Rabbie Burns stands here. It is intriguing to imagine the poet among the boats as an excise man, checking cargoes and vessels, the loading and unloading, striding about between strings of pack horses and carts.

Waterfoot also saw something of the cross-border cattle trade. Thousands were driven across the Solway from around this point for sale in the south, and by going across the sands the toll bridges were avoided.

Looking towards Bowness from Annan, close to the old crossing. (*Courtesy Mr M. Coupe*)

Remnant of the old viaduct. (*Courtesy Mr M. Coupe*)

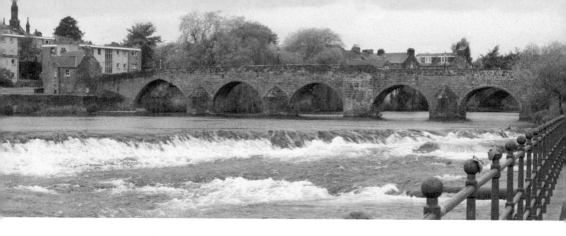

The River Nith with its weirs, and the lovely Devorgillas Bridge.

Although there was no harbour as such, there was a jetty, where the regular (as far as weather permitted) passenger crossings to and from Bowness were accommodated, as were thousands of passengers bound for Australia, New Zealand and Canada, during the great emigrations of the eighteenth and nineteenth centuries.

Waiting passengers were in the habit of seeking refreshment and sometimes accommodation at the inn at Waterfoot Farm. This building was said to have specially deepened cellars designed to store contraband. It is tempting to wonder how much the local excise either knew or suspected.

For me, to think of Burns as an excise man on the shores of the Nith Estuary somehow turns this folk hero into a realistic person. But, of course, Burns will forever be associated with Dumfries.

Dumfries

Dumfries was created a Royal Burgh in the twelfth century. The name says something of the city's past, translating as 'woodland stronghold'.

The River Nith snakes through Dumfries, the city that will forever be associated with Burns. We are told that the poet did much of his work here, although he lived in the city for a mere five or six years, from 1791 until his death. I have found differing dates for Burns and his time in the city.

The Burns Mausoleum at St Michael's church, where he lies with his wife and several of their children, is world famous. This monument was completed in 1817.

In spite of being around 7 miles from the estuary, in the past Dumfries was intimately associated with the Solway, being one of the busiest ports on this northern side. One of its outports, Carsethorn, acted as quarantine port for the whole of the Solway; In Carsethorn,

Whitehaven ships were held and cleared during one particularly vicious yellow fever epidemic.

Now, alas, the shipping that plied the Nith is no more.

Most people will know of the famous and picturesque bridge, and recognise the name 'white sands', no longer white or sands. Things move on, and the city is still a place of interest and history. The camera obscura, installed above the museum in 1836, is also well know. I admit that, until recently, I did not realise that this famous landmark resided on the top floor of a windmill tower.

The fine bridge over the weirs in Dumfries is the lovely Devorgillas Bridge, built from her munificence. Her resting place, Sweetheart Abbey lies close to Criffle, and I make no excuse for telling its story, in spite of it being so well known. It is a wonderful tale, simple and true.

If I am to keep in geographical order, I should put the mighty Caerlaverock Castle and estates first. The castle and Sweetheart Abbey lie either side of the Nith Estuary below Dumfries, but I think that order may bow its head to a love story.

Sweetheart Abbey

Devorgilla was married to John Balliol when she was fifteen years old. Both families were hugely wealthy. During their time together, they moved between and lived in a number of places, including John's home in Picardy.

After forty wonderful, happy years, Devorgilla was widowed, leaving her fabulously wealthy. Taking in to account the age in which she lived, there must have been pressure for her to marry again, but there was only one person with whom she had ever wished to share her life.

John Balliol's body was embalmed and his heart placed in a golden casket, which accompanied Devorgilla constantly. On her death, it was placed in her coffin and they now lie together in Sweetheart Abbey, the abbey she had built in her husband's memory. It has been said many times that it is one of the world's best known and most enduring love stories.

Sweetheart Abbey lies close to Criffel, and in the excellent *The Lore of Scotland*, by Westwood and Kingshill. The tradition that this great edifice was caused by the Devil is quoted.

This tale tells how the wizard Michael Scot, in an effort to keep the fiend constantly busy, tasked the Devil with building a causeway over the Solway Firth. It was while flying over the River Nith that the rope holding the Devil's creel broke, causing the rocks that he was carrying to land in a heap and form the mountain Criffel (or 'Creel-Fell').

Caerlaverock Castle

First mentioned around 1220, but dating mainly from the fifteenth century, and owned by the powerful Maxwells, Caerlaverock was a major Reiver stronghold of strategic and political importance. This castle has changed hands on numerous occasions and its history of conflict is long and stormy, lasting several hundred years.

The following are two examples of Caerlaverock's most famous, or infamous, incidents. It was attacked, held to siege and taken by Edward I in 1300. Over 300 years and many battles later, it was the Covenanters who were responsible for Caerlaverock's final siege, which lasted some three months and took place in 1640.

The enclosure of the building is unusual, being triangular in plan, and 'Ellangowan', which features in Sir Walter Scott's *Guy Mannering* is thought to be based on Caerlaverock.

Now under the care of Historic Scotland, Caerlaverock is surrounded by a wonderful nature reserve that bears its name.

Caerlaverock Wildfowl and Wetlands Trust Centre

Opened in autumn 1970, and found by Sir Peter Scott, the nature reserve extends for some 1,400 acres and is part bordered by the Solway.

Caerlaverock provides a year-round spectacle – wonderful wildflower meadows, attracting dragonflies and butterflies. There are willow warblers, sedge warblers, skylarks, ospreys, barn owls and much more. The colder months bring over wintering birds, including barnacle geese and whooper swans.

Having commented on how advantages the area around Port Carlisle appears for smuggling purposes, I hope that I will be forgiven for commenting that the beautiful shores of Dumfries and Galloway, with their numerous nooks and crannies, appear to have been designed for smugglers. They would make a wonderful backdrop for a film on the subject.

I have recently come across two fascinating maps of this coastline: the first is a map of the Galloway Sea Board, printed by Dinwiddie & Co. Dumfries and credited to John A. Copeland (1970). To the best of my memory, I have never seen a map with so much clearly marked historical information and old local names that I have never seen before (e.g. Palnackie bracketed as 'Devils Creek'). It shows smuggling localities, caves coastguard stations, barracks and much more, including a spider's web of smugglers' tracks. Sadly, the company who produced it no longer exist, so it is almost impossible to get a copy, or to obtain permission to print. For anyone interested in the subject, it is well

worth trying local libraries and other sources. The second map is easier to obtain. Once again, I acknowledge 'The Lore of Scotland' Westwood and Kinghill. The map in question shows the location of places and strange things of interest, ghosts, fantastic creatures, witches, legends, and everything from mermaids to saints.

The width and variety shown is quite fantastic. One thing that is immediately obvious and quite fascinating are the differences in the folklore and legends on either side of the Solway. The Scots side appears to have a greater variety of fantastical creatures than the English shores.

Mermaids

Cumbria has Sea Wives, Dumfries and Galloway has Mermaids. These are not the pretty, sanitised creatures of contemporary children's books and films, but long-haired, singing sirens that can be both vicious and dangerous.

The Scots side of the Solway is just as treacherous as the English, so I suppose we could almost expect folklore that contains warnings. I have heard of mermaids at Rockcliff (Scotland) and in Luce Bay. Both are reputed to take children as well as young men.

Westwood and Kingshill, whose excellent book covers the length and breadth of Scotland, speak of both mermaids and 'selkies'. There are neither stories nor traditions of selkies in the Solway (as far as I am aware), but their habit of passing to and from their realm beneath the waves in the guise of seals, is remarkably similar to the folklore concerning Sea Wives and their magical cloaks.

Selkies cast off their skin and turn from seal to human. To find and retain this skin is to bind the creature to this human realm – so with the Sea Wife and her magical cloak. It is irresistible not to speculate that, at some point in the past, this folklore probably had a common root.

It would appear that some of the mermaids of Dumfries and Galloway occupy streams as well as the shoreline. One of the stories quoted in *The Lore of Scotland* is that of the 'Mermaid of Galloway', who made her home in Dalbeattie Burn, Kirkcudbrightshire.

This particular creature could be helpful, giving advice and recipes for healing. Similar to most of her kind, this mermaid had long, golden hair, which she delighted in combing, and as is the way with sirens, to look at her was to love her. Her favoured place was a rock in a pool at the mouth of the burn, where she delighted to sit and comb her hair by the light of the new moon.

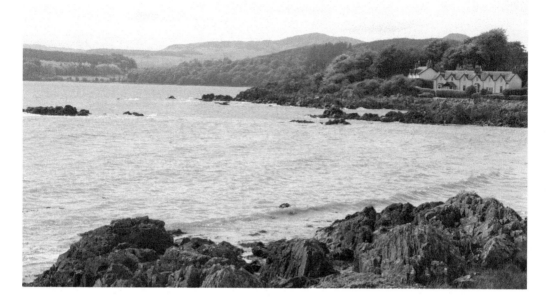

The beautiful beach at Rockcliff, supposedly favoured by mermaids, looking out across Rough Firth. (*Courtesy Dr P. K. Ivision*)

A pious woman of the neighbourhood took offence to this supernatural creature, and tipped the granite rock on which the mermaid habitually sat into the bottom of the pool. Revenge was swift; within a day this woman's only child lay dead

Southerness

Southerness, also known as Satterness, lies away from the main road at Southerness Point. A lighthouse once overlooked this rocky coastline near Gillfoot bay. The A710 takes you across the headland, then a side road to Rockcliff and Castle Hill Point, and eventually to Dallbeatie – but there is much to see on the way.

Rockcliff

As already obvious, there are two Rockcliffs on the Solway – one on either side – English and Scots. The English Rockcliff lies close to the River Eden, while the Scots Rockcliff overlooks the next estuary, to the lovely Auchencairn Bay. An old AA road book states that Rockcliff is 'on Rough Firth, the estuary of the Urr Water', which I think is a wonderful land-precise description. The same publication mentions 'The Mote of Mark', the site of a prehistoric vitrified fort and well-marked on most maps.

Its shinning cliffs are often visible from across the firth.

Palnackie

Palnackie was a Solway port. I hope that no one objects to the word 'was', for like others it is silted up beyond commercial use. It also lies on a creek of the Rough Firth. Granite for the Thames embankment came from the nearby Craignair granite quarries close to Dallbeatie.

Dalbeattie

Dalbeattie is a town built of granite and originally a Solway port. Dalbeattie's meaning is 'haugh by the birchwood', which I have often thought sounds rather picturesque.

Dalbeattie stone was shipped worldwide from the now silted harbour. The town lies in the valley of the Urr Water, and the A711 runs from Dalbeattie to Kirkcudbright with wonderful views all the way.

A network of smugglers' tracks covered this section of coast, and I have no doubt as to some of them being preserved in the line of various footpaths and tracks. The line of one appears very similar to that taken by the A711 via Kippford, skirting the beautiful Auchencairn bay.

Rough Island from Rockcliff. The beach here is made almost entirely of small, white shells. (*Courtesy Dr P. K. Ivision*)

Kippford

A side road takes you to Kippford Bay, which is small and rocky. In the not so distant past, there was a mill, quarry, port and shipyard at Kippford. I admit to sometimes forgetting just how many small (and not so small) working ports there were around the Firth. Many are still in used, now mainly for pleasure. Orchardton tower stands close to Kippford. This fifteenth-century tower is unusual in being circular and it is reputed to have strong associations with Scot's *Guy Mannering*.

Auchencairn Bay

Yet another literary reference belongs to Heston Island in Auchencairn Bay. Heston was the model described as 'Isle Rathan' in *Raiders* by S. R. Crockett. Achencairn is a pretty village with a lovely bay, and there is also an ancient burial cairn here. 'Auchen' is sometimes used to designate a personal reference or use.

Balcary

Balcary Bay is a small inlet at the mouth of Auchencairn, sheltered by Balcary point. This bay is overlooked by a tower that shares its name with a private residence. It must be one of the most enviable locations in the area.

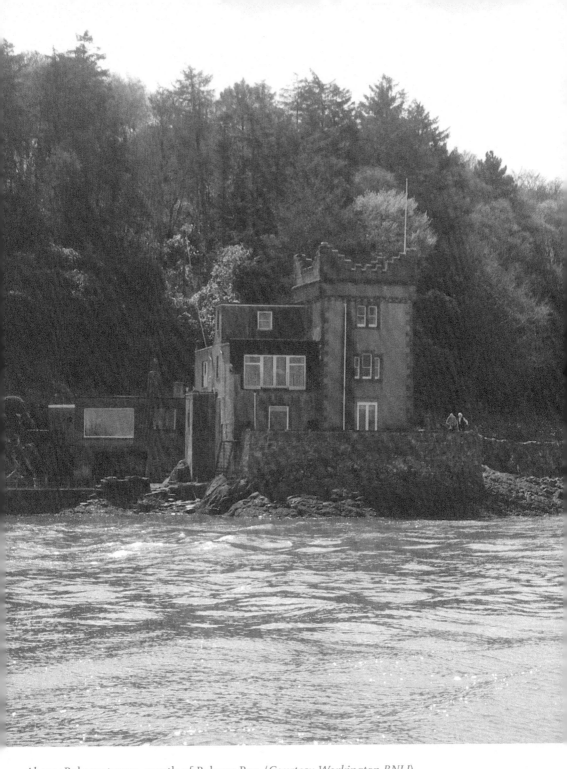

Above: Balcary tower, mouth of Balcary Bay. (*Courtesy Workington RNLI*)

Opposite: Heston Island, looking to Auchencairn Bay. (*Courtesy Dr P. K. Ivision*)

Abbey foot, looking towards Skiddaw. It was close to this spot that Mary, Queen of Scots, embarked on her fateful journey. (*Courtesy of Mr M. Coupe*)

Dundrennan

Warning signs and 'danger area' printed across the map show the MOD's presence near the village of Dundrennan. Coincidently, the 'dun' in Dundrennan probably means fort.

History tells that Mary, Queen of Scots, spent her last night in Scotland at Dundrennen Abbey. In his book *The Solway Firth*, Brian Blake suggests that although she may have been welcomed at the Cistercian Abbey, it is possible that she spent the night at Terregles, the home of Lord Herries, one of the queen's most loyal supporters.

There are so many differing strands, opinions and speculations in the story of Mary's escape, but Blake might well be right. Some versions of the Queen's flight state that she borrowed, 'male garments' from Herries, and cropped her hair to disguise herself. It might well have been so, and she could have been in dire need of fresh garments after spending some days sleeping rough in the heather after her defeat at Langside.

Yet there is a possibility that the 'men's' cloths were practical, it was far from uncommon for women in the Borders to ride booted and breached – it was and is – rough country, and Mary had been in battle. Also, she had been ill after a miscarriage. It was common to have your hair cropped after such a trauma

We will probably never quite come to final proven conclusions surrounding the possible details of the royal flight. Did they or did they

84

not take horses? If not were mounts waiting on the English shore for the party? Was the Queen expected? How many people accompanied Mary? All these details and more are speculated over endlessly.

If there is a certainty, it is that Mary Stuart, Queen of Scots, and Queen Dowager of France, left her native land on a certain May evening in 1568, never to return. The point of her departure is widely agreed to have been Burn Foot.

Beyond Dundrennan is Kirkcudbright bay, fed by the River Dee.

Kirkcudbright

'The church of St Cuthbert': what better meaning for a town set in such a place? Not only was there a monastery in Kirkcudbright (c. 1100) but a Augustinian priory and a Cistercian nunnery.

A sub-port of Dumfries, nevertheless, Kirkcudbright held its own registration until 1841. In the past much of the town's wealth came from shipping, its wonderful sheltered bay and secure quays on the mouth of the Dee must have been attractive in more unstable times. I am delighted to say that there are still fishing boats in Kirkcudbright's harbour.

I find some of the names on maps of Kircudbright Bay fascinating – Nun Mill, Goat Bay Well, Devil's Threshing Floor, Frenchman's Rock and Manxmans Lake – to mention just some; they seem to indicate a varied and interesting past.

My wonderful old gazetteer describes Kircudbright as a market town, Royal Burgh and the most important town in the Stewartry. It also tells us that the town and castle were attacked by Manx pirates in the early 1500s, this makes me wonder about 'Manxman's Lake'?

Another point of interest, Paul Jones, of Whitehaven and American navy fame, was jailed here. Kirkbean, the birth place of Paul Jones, is close by. The American Navy presented a memorial font to the local church here, in 1945.

This pretty town in its picturesque setting attracts artists and craftsman. Some of the tourist literature describes it as the 'Artists' Town of Kircudbright', and speak of it as 'home to an established artist colony in the nineteenth and twentieth centuries. Art is still very much here.

Joining the A75 to Newton Stewart is probably the simplest (though possibly not the shortest) way to get from Kircudbright to Whithorn. There is a plethora of ways, choice depends on inclination and time available. But whatever choice is made, the A75 is recommended at least part way, it is a scenic way to get around Wigton Bay and needed to cross the river Cree. Leaving the A75 at Newton Stewart, given time, I like to visit Wigtown on my way to Whithorn.

Above and below: Ross Island, Kirkcudbright Bay.

Opposite: An evocative statue by Kirkcudbright Harbour: To those who have lost their lives at sea. (*Courtesy Dr P. K. Ivison*)

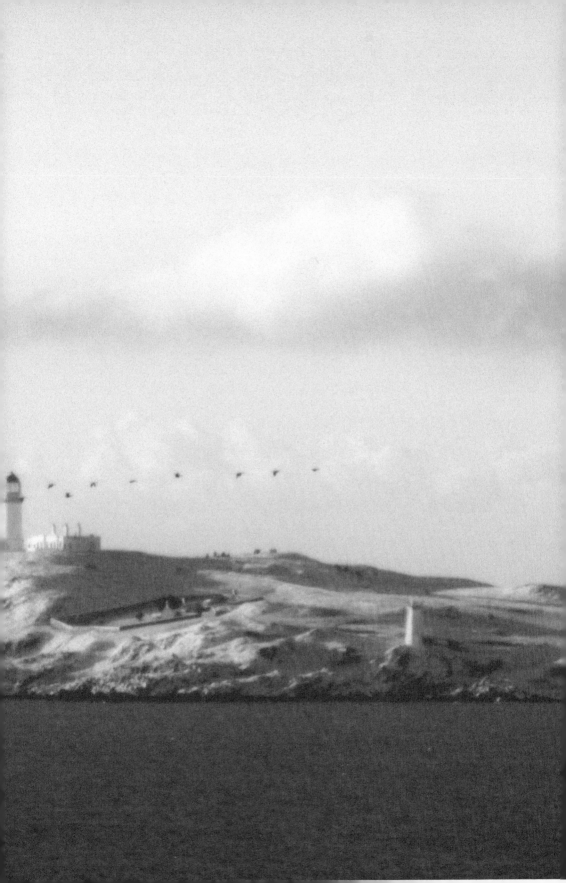

Above: Ross Island, 'Reflections'.

Below: Laying in Kirkcudbright Bay. (*Courtesy Mr T. Thompon*)

Previous page: Ross Island Lighthouse, Kirkcudbright Bay. (*Courtesy of Mr M. Coupe*)

Kirkcudbright harbour. (*Courtesy of Mr M. Coupe*)

Wigtown

There is a 'Wigton' in Cumbria. The 'ton' is common, meaning a village or possibly a farmstead. The 'Wig' is probably a corrupted version of a personal name, name and dwelling place being a frequent combination.

Standing beside Wigtown Bay, close to the River Bladnoch Estuary, the town was created a Royal Burgh in 1457. In 1855, Wigtown was created a Solway Port in its own right.

The 'Wigtown Martyrs': in 1685, Margaret McLauchlan and Margaret Wilson, a woman and a young girl respectively, were tied to stakes and drowned at the mouth of the Bladnoch for their Covenanter beliefs.

4

Whithorn

The Isle of Whithorn

An old Royal Burgh on the Machars peninsula, the village and the 'isle' are so often spoken of as one, despite the (short) distance between them. Like so many people, I think of them as one indivisible place.

Whithorn is 'Candida Casa', meaning the White House or Shining House depending on whom you read. Named for the chapel built by Ninian, Scotlands first saint, around 397, it is said to have been the first stone-built church in Scotland. The 'white' or 'shining' is said to come from the probability of the chapel being covered in white plaster. In the 1940s, some stones were found with evidence of this.

Ninian, who was born on the northern shores of the Solway, was said to be the son of a chieftain. What is known of the saint's life comes from the writings of a twelfth-century monk, Ailred of Reavaulx, who lived in Scotland for a period under the patronage of Queen Margaret.

After his death, Ninian's Shrine was taken over successively and successfully by Northumbrians, Vikings and Scots. A cathedral built to house the saint's remains now lies in ruins.

The saint, who in our modern times is the subject of some debate, attracted powerful pilgrims in the past. Chief among them must be King James IV of Scotland, the last British monarch to lose his life in battle. He was to die at Flodden.

Housing the relics of a saint brought both pilgrims and revenue, and during medieval times the priory and its estates were rich, and Whithorn boasted a prosperous port. We are told that a pilgrim chapel was built on the headland (c. 1300) to welcome those who wished to honour the saint.

Today, Whithorn both celebrates its past and embraces its future. Still a place of pilgrimage, it is also a place of art and culture.

The Isle of Withhorn and St Bees are two religious houses sitting north and south across the jaws of the Solway Firth. In the past, passage between them was an everyday event – weather permitting.

Whithorn, St Bees, Ninian and Bega: I have no wish to enter any opinion or argument when I say that there are academics who speculate whether they ever actually existed. They are both part of the history of the Solway, and their fame (if that is the right word) stretches far beyond this 'most beautiful and dangerous of seas'. Perhaps that says something of our Celtic past, but I do rather like the fact that one is male and the other female.

Looking across Wigtown Bay towards the Isle of Whithorn. (*Courtesy Dr P. K. Ivison.*)

Although relatively small geographically, the richness of the Solway Firth, its history and culture, is immense. At this point, I am very aware of those things that I wish I had had space for, and wonder at the decisions on what to put in what to leave out.

There are the wonderful stone crosses, the enigma of the cup and ring stones, and the Isle of Man. While not perhaps strictly part of the Solway, its role in its history and economics is fascinating. I have mentioned its role in the economy of the smuggling trade when the island virtually acted as a warehouse for the area.

It might come as a surprise to some that the Solway is a UFO hotspot, as testified by a website and some newspaper accounts.

The great Firth has seen the Norse, the Romans and the Normans among others, and all have added to its history and culture. We are told that *Sol-vagr-Sulewad* (muddy bay, muddy crossing) was named so by the Norse.

To those who now live on the Solway Firth's shore, and are privileged to sometimes watch it turn into a sea of gold, it will always be Sol, the sun's, way.

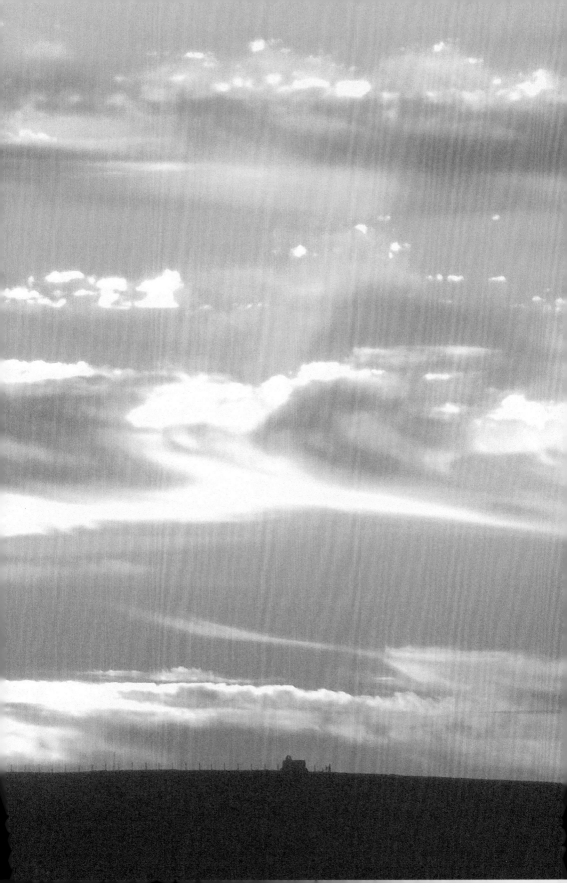

ALSO AVAILABLE FROM AMBERLEY PUBLISHING

EXMOUTH *to* PLYMOUTH

Gary Holpin

This unique selection of images and informative text is essential reading for anyone who knows and loves this beautiful stretch of Britain's coastline.

978 1 4456 2151 7
96 pages, full colour

Available from all good bookshops or order direct from our website www.amberleybooks.com